Pro·Lighting

NEW PRODUCT SHOTS

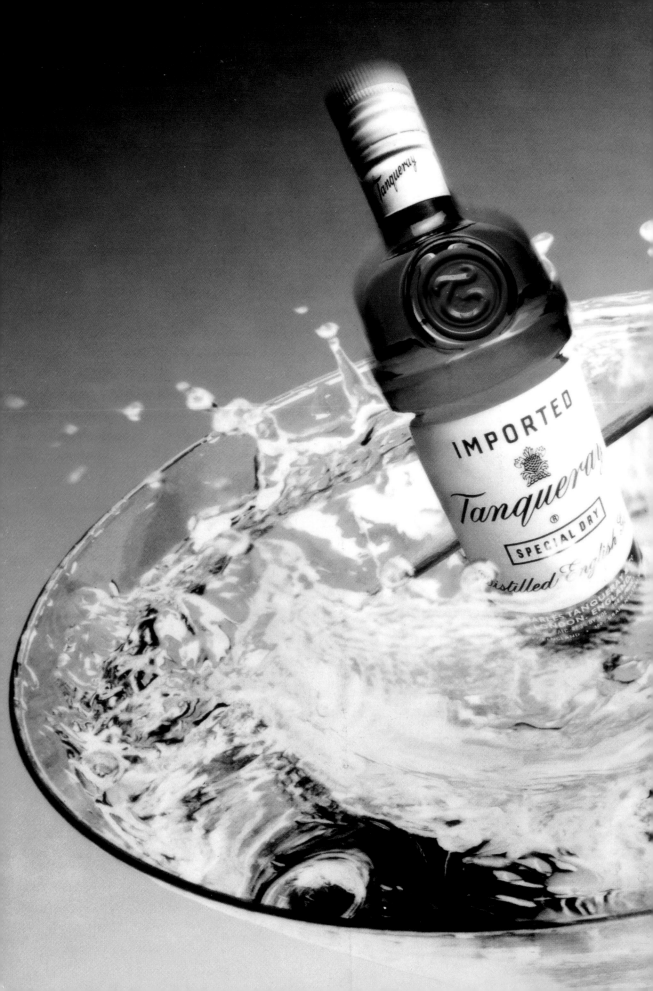

Pro·Lighting

ALEX LARG and JANE WOOD

NEW PRODUCT SHOTS

RotoVision

A Quintet Book

Published and distributed by
RotoVision SA
Rue du Bugnon 7
CH-1299 Crans-Près-Céligny
Switzerland

RotoVision SA Sales & Production office
Sheridan House
112/116A Western Road
Hove, East Sussex BN3 1DD, UK
Tel: +44 (0)1273 72 72 68
Fax: +44 (0)1273 72 72 69
e-mail: sales@RotoVision.com

Distributed to the trade in the United States by
Watson-Guptill Publications
1515 Broadway
New York, USA. NY 10036

1 3 5 7 9 10 8 6 4 2

ISBN 2-88046-372-6

This book was designed and produced by
Quintet Publishing Limited
6 Blundell Street
London N7 9BH

Creative Director: Richard Dewing
Art Director: Clare Reynolds
Designer: James Lawrence
Project Editor: Keith Ryan
Picture Research: Alex Larg, Jane Wood, Keith Ryan,
Victoria Hall

Printed in Singapore
Production and Separation by ProVision Pte. Ltd.
Tel +65 334 7720
Fax +65 334 7721

CONTENTS

THE PRO-LIGHTING SERIES

The most common response from the photographers who contributed to this book, when the concept was explained to them, was "I'd buy that". The aim is simple: to create a library of books, illustrated with first-class photography from all around the world, which show exactly how each individual photograph in each book was lit.

Who will find it useful? Professional photographers, obviously, who are either working in a given field or want to move into a new field. Students, too, who will find that it gives them access to a very much greater range of ideas and inspiration than even the best college can hope to present. Art directors and others in the visual arts will find it a useful reference book, both for ideas and as a means of explaining to photographers exactly what they want done. It will also help them to understand what the photographers are saying to them. And, of course, "pro/am" photographers who are on the cusp between amateur photography and earning money with their cameras will find it invaluable: it shows both the standards that are required, and the means of achieving them.

The lighting set-ups in each book vary widely, and embrace many different types of light source: electronic flash, tungsten, HMIs, and light brushes, sometimes mixed with daylight and flames and all kinds of other things. Some are very complex; others are very simple. This variety is very important, both as a source of ideas and inspiration and because each book as a whole has no axe to grind: there is no editorial bias towards one kind of lighting or another, because the pictures were chosen on the basis of impact and (occasionally) on the basis of technical difficulty. Certain subjects are, after all, notoriously difficult to light and can present a challenge even to experienced photographers. Only after the picture selection had been made was there any attempt to understand the lighting set-up.

This book is a part of the fifth series: EROTICA, FASHION SHOTS and NEW PRODUCTS SHOTS. Previous titles in the series include INTERIOR SHOTS, GLAMOUR SHOTS, SPECIAL EFFECTS, NUDES, PRODUCT SHOTS, STILL LIFE, FOOD SHOTS, LINGERIE SHOTS, PORTRAITS, BEAUTY SHOTS, NIGHT SHOTS and NEW GLAMOUR. The intriguing thing in all of them is to see the degree of underlying similarity and diversity to be found in a single discipline or genre.

Erotica features the entire range of erotic imagery, from fetish to fashionable, from the particular to the general, from subtle suggestion to overt sexuality. Fashion Shots examines the implications this fickle and ever-changing subject can have on photography. Fashion changes with each passing year and each trend changes the images being sold, as this collection of photographs reveals. New Product Shots takes on the challenge of commercial photography in all its guises, asking the question: what is being sold? Is it the image of the product itself? In all three titles, the key is the lighting used, but the set-ups are not the real focus. As always, it is the photographer that takes centre stage.

The structure of the books is straightforward. After this initial introduction, which changes little among all the books in the series, there is a brief guide and glossary of lighting terms. Then, there is specific introduction to the individual area or areas of photography which are covered by the book. Sub-divisions of each discipline are arranged in chapters, inevitably with a degree of overlap, and each chapter has its own introduction. Finally, there is a directory of those photographers who have contributed work.

If you would like your work to be considered for inclusion in future books, please write to Quintet Publishing Ltd, 6 Blundell Street, London N7 9BH and request an Information Pack. DO NOT SEND PICTURES, either with the initial inquiry or with any subsequent correspondence, unless requested; unsolicited pictures may not always be returned. When a book is planned which corresponds with your particular area of expertise, we will contact you. Until then, we hope that you enjoy this book; that you will find it useful; and that it helps you in your work.

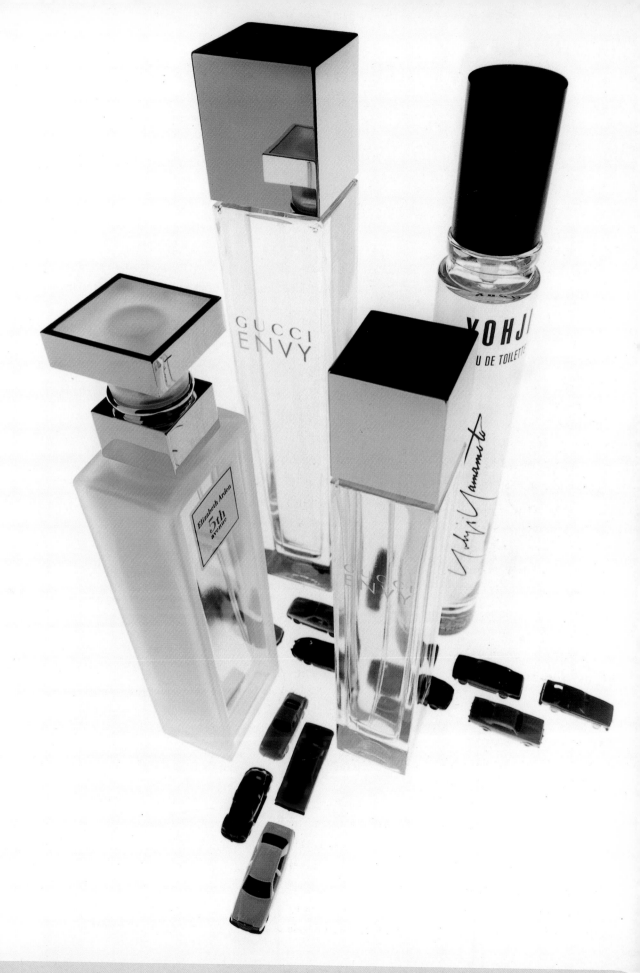

HOW TO USE THIS BOOK

The lighting drawings in this book are intended as a guide to the lighting set-up rather than as absolutely accurate diagrams. Part of this is due to the variation in the photographers' own drawings, some of which were more complete (and more comprehensible) than others, but part of it is also due to the need to represent complex set-ups in a way which would not be needlessly confusing.

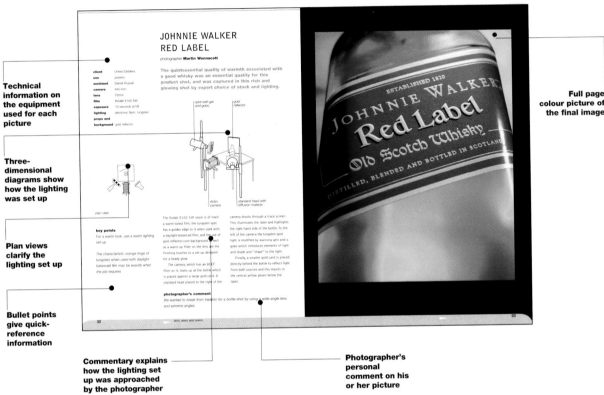

Technical information on the equipment used for each picture

Three-dimensional diagrams show how the lighting was set up

Plan views clarify the lighting set up

Bullet points give quick-reference information

Commentary explains how the lighting set up was approached by the photographer

Photographer's personal comment on his or her picture

Full page colour picture of the final image

Distances and even sizes have been compressed and expanded: and because of the vast variety of sizes of soft boxes, reflectors, bounces and the like, we have settled on a limited range of conventionalized symbols. Sometimes, too, we have reduced the size of big bounces, just to simplify the drawing.

None of this should really matter, however. After all, no photographer works strictly according to rules and preconceptions: there is always room to move this light a little to the left or right, to move that light closer or

further away, and so forth, according to the needs of the shot. Likewise, the precise power of the individual lighting heads or (more important) the lighting ratios are not always given; but again, this is something which can be "fine tuned" by any photographer wishing to reproduce the lighting set-ups in here.

We are however confident that there is more than enough information given about every single shot to merit its inclusion in the book: as well as purely lighting techniques, there are also all kinds of hints and tips about commercial realities, photographic

practicalities, and the way of the world in general.

The book can therefore be used in a number of ways. The most basic, and perhaps the most useful for the beginner, is to study all the technical information concerning a picture which he or she particularly admires, together with the lighting diagrams, and to try to duplicate that shot as far as possible with the equipment available.

A more advanced use for the book is as a problem solver for difficulties you have already encountered: a

particular technique of back lighting, say, or of creating a feeling of light and space. And, of course, it can always be used simply as a source of inspiration.

The information for each picture follows the same plan, though some individual headings may be omitted if they were irrelevant or unavailable. The photographer is credited first, then the client, together with the use for which the picture was taken. Next come the other members of the team who worked on the picture: stylists, models, art directors, whoever. Camera and lens come next, followed by film. With film, we have named brands and types, because different films have very different ways of rendering colours and tonal values. Exposure comes next: where the lighting is electronic flash, only the aperture is given, as illumination is of course independent of shutter speed. Next, the lighting equipment is briefly summarized — whether tungsten or flash, and what sort of heads — and finally there is a brief note on props and backgrounds. Often, this last will be obvious from the picture, but in other cases you may be surprised at what has been pressed into service, and how different it looks from its normal role.

The most important part of the book is however the pictures themselves. By studying these, and referring to the lighting diagrams and the text as necessary, you can work out how they were done; and showing how things are done is the brief to which the Pro Lighting series was created.

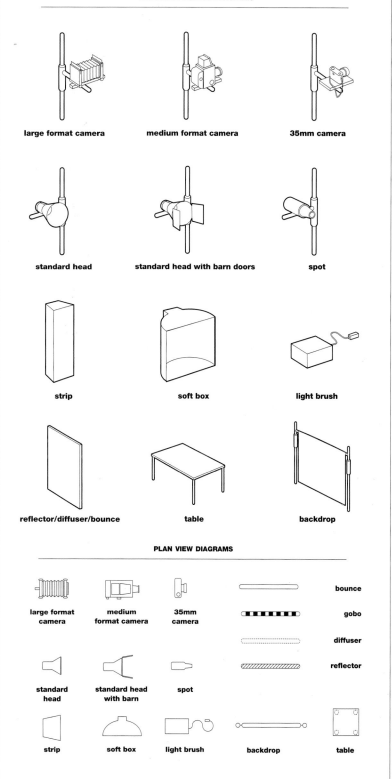

DIAGRAM KEY

The following is a key to the symbols used in the three-dimensional and plan view diagrams. All commonly used elements such as standard heads, reflectors etc., are listed. Any special or unusual elements involved will be shown on the relevant diagrams themselves.

THREE-DIMENSIONAL DIAGRAMS

large format camera medium format camera 35mm camera

standard head standard head with barn doors spot

strip soft box light brush

reflector/diffuser/bounce table backdrop

PLAN VIEW DIAGRAMS

large format camera medium format camera 35mm camera bounce

gobo

diffuser

standard head standard head with barn spot reflector

strip soft box light brush backdrop table

GLOSSARY OF LIGHTING TERMS

Lighting, like any other craft, has its own jargon and slang. Unfortunately, the different terms are not very well standardized, and often the same thing may be described in two or more ways or the same word may be used to mean two or more different things. For example, a sheet of black card, wood, metal or other material which is used to control reflections or shadows may be called a flag, a French flag, a donkey or a gobo – though some people would reserve the term "gobo" for a flag with holes in it, which is also known as a cookie. In this book, we have tried to standardize terms as far as possible. For clarity, a glossary is given below, and the preferred terms used in this book are asterisked.

Acetate
see Gel

Acrylic sheeting
Hard, shiny plastic sheeting, usually methyl methacrylate, used as a diffuser ("opal") or in a range of colours as a background.

***Barn doors**
Adjustable flaps affixed to a lighting head which allow the light to be shaded from a particular part of the subject.

Barn doors

Boom
Extension arm allowing a light to be cantilevered out over a subject.

***Bounce**
A passive reflector, typically white but also, (for example) silver or gold, from which light is bounced back onto the subject. Also

used in the compound term "Black Bounce", meaning a flag used to absorb light rather than to cast a shadow.

Continuous lighting
What its name suggests: light which shines continuously instead of being a brief flash.

Contrast
see Lighting ratio

Cookie
see Gobo

***Diffuser**
Translucent material used to diffuse light. Includes tracing paper, scrim, umbrellas, translucent plastics such as Perspex and Plexiglas, and more.

Electronic flash: standard head with diffuser (Strobex)

Donkey
see Gobo

Effects light
Neither key nor fill; a small light, usually a spot, used to light a particular part of the subject. A hair light on a model is an example of an effects (or "FX") light.

***Fill**
Extra lights, either from a separate head or from a reflector, which "fills" the shadows and lowers the lighting ratio.

Fish fryer
A small Soft Box.

***Flag**
A rigid sheet of metal, board, foam-core or other material which is used to absorb light or to create a shadow. Many flags are painted black on one side and white (or brushed silver) on the other, so that they can be used either as flags or as reflectors.

***Flat**
A large Bounce, often made of a thick sheet of expanded polystyrene or foam-core (for lightness).

Foil
see Gel

French flag
see Flag

Frost
see Diffuser

***Gel**
Transparent or (more rarely) translucent coloured material used to modify the colour of a light. It is an abbreviation of "gelatine (filter)", though most modern "gels" for lighting use are actually of acetate.

***Gobo**
As used in this book, synonymous with "cookie": a flag with cut-outs in it, to cast interestingly-shaped shadows. Also used in projection spots.

"Cookies" or "gobos" for projection spotlight (Photon Beard)

***Head**
Light source, whether continuous or flash. A "standard head" is fitted with a plain reflector.

***HMI**
Rapidly-pulsed and

effectively continuous light source approximating to daylight and running far cooler than tungsten. Relatively new at the time of writing, and still very expensive.

*Honeycomb

Grid of open-ended hexagonal cells, closely resembling a honeycomb. Increases directionality of

Honeycomb (Hensel)

light from any head.

Incandescent lighting

see Tungsten

Inky dinky

Small tungsten spot.

*Key or key light

The dominant or principal light, the light which casts the shadows.

Kill Spill

Large flat used to block spill.

*Light brush

Light source "piped" through fibre-optic lead. Can be used to add highlights, delete shadows and modify lighting, literally by "painting with light".

Electronic Flash: light brush "pencil" (Hensel)

Electronic Flash: light brush "hose" (Hensel)

Lighting ratio

The ratio of the key to the fill, as measured with an incident light meter. A high lighting ratio (8:1 or above) is very contrasty, especially in colour, a low lighting ratio (4:1 or less) is flatter or softer. A 1:1 lighting ratio is completely even, all over the subject.

*Mirror

Exactly what its name suggests. The only reason for mentioning it here is that reflectors are rarely mirrors, because mirrors create "hot spots" while reflectors diffuse light. Mirrors (especially small shaving mirrors) are however widely used, almost in the same way as effects lights.

Northlight

see Soft Box

Perspex

Brand name for acrylic sheeting.

Plexiglas

Brand name for acrylic sheeting.

*Projection spot

Flash or tungsten head with projection optics for casting a clear image of a gobo or cookie. Used to create textured lighting effects and shadows.

*Reflector

Either a dish-shaped

surround to a light, or a bounce.

*Scrim

Heat-resistant fabric

Electronic Flash: projection spotlight (Strobex)

Tungsten Projection spotlight (Photon Beard)

diffuser, used to soften lighting.

*Snoot

Conical restrictor, fitting over a lighting head. The light can only escape from the small hole in the end, and is

therefore very directional.

*Soft box

Large, diffuse light source made by shining a light

Tungsten spot with conical snoot (Photon Beard)

Electronic Flash: standard head with parallel snoot (Strobex)

through one or two layers of diffuser. Soft boxes come in all kinds of shapes

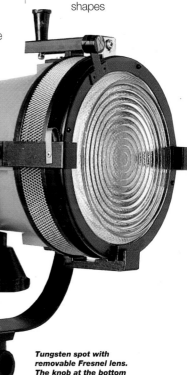

Tungsten spot with removable Fresnel lens. The knob at the bottom varies the width of the beam (Photon Beard)

Electronic flash: standard head with large reflector and diffuser (Strobex)

and sizes, from about 30x30cm to 120x180cm and larger. Some soft boxes are rigid; others are made of fabric stiffened with poles resembling fibreglass fishing rods. Also known as a northlight or a windowlight, though these can also be created by shining standard heads through large (120x180cm or larger) diffusers.

***Spill**

Light from any source which ends up other than on the subject at which it is pointed. Spill may be used to provide fill, or to light backgrounds, or it may be controlled with flags, barn doors, gobos etc.

***Spot**

Directional light source. Normally refers to a light using a focusing system

Tungsten spot with safety mesh (behind) and wire half diffuser scrim (Photon Beard)

with reflectors or lenses or both, a "focusing spot", but also loosely used as a reflector head rendered more directional with a honeycomb.

***Strip or strip light**

Lighting head, usually flash, which is much longer than it is wide.

Electronic flash: strip light with removable barn doors (Strobex)

Strobe

Electronic flash. Strictly, a "strobe" is a stroboscope or rapidly repeating light source, though it is also the name of a leading manufacturer:

Strobex, formerly Strobe Equipment.

Swimming pool

A very large Soft Box.

***Tungsten**

Incandescent lighting. Photographic tungsten

Electronic flash: standard head with standard reflector (Strobex)

lighting runs at 3200°K or 3400°K, as compared with domestic lamps which run at 2400°K to 2800°K or thereabouts.

***Umbrella**

Exactly what its name suggests; used for modifying light.

Umbrellas may be used as reflectors (light shining into the umbrella) or diffusers (light shining through the umbrella). The cheapest way of creating a large, soft light source.

Windowlight

Apart from the obvious meaning of light through a window, or of light shone through a diffuser to look as if it is coming through a window, this is another name for a soft box.

NEW PRODUCT SHOTS

In a sense, almost any commercial shot can be defined as a product shot. If there is a commercial application for the shot, it follows that there must be a product, even if the product is the shot itself. Starting with such a broad definition, then, how do we pull in the boundaries a little and describe what, more precisely, is in practice meant by the term 'product shot'?

The answer, it seems, that everyone knows what a product shot is, but nobody can exactly tell you what it is. Every time one tries to define the parameters, an exception can readily be found to debunk the definition. Perhaps a product shot has to involve a named, branded product. Well, no; many shots that involve very specific products are not actually branded; the products may be generic, such as pasta, for example, rather than a specific make of pasta.

Well, then, perhaps a product shot is one that promotes a solid, visible artefact, whether branded or unbranded. Well, no; some product shots are promoting an intangible product, such as a flavour or a perfume, and the solid visible artefact in the shot is only a representative of the important feature of the product, so that definition falls short too.

In that case, maybe we can say that a product shot depicts a tangible or intangible aspect of a commodity, directly or indirectly.

But even that definition falls short, for it may well be that the product being promoted may be the one thing that is actually not included in the shot at all. The famous world-wide Benetton campaigns, for example, are instantly recognisable as representing the Benetton company and products, yet not a single Benetton-made item features in many of the most compelling campaign shots. The same can be said for many tobacco advertisements, as well as jeans, drinks, and so on. In these cases, the branding is so firmly established in the consumers mind, purely by the styling and 'look' of the advertisement, that the product itself does not need to be in the image. So we reach the conclusion that a product shot does not even necessarily have to include a product in it.

This may seem a rather unsatisfying 'dead end' to reach, but it is important to think about definitions when approaching product shots if only to realise that the term, precise and even restrictive as it may sound, is in fact a license for an enormous amount of freedom as a photographer. Far from being a restricted genre of catalogue and poster pack-shots (a term that, by contrast, is all too easily defined), a product shot can include anything from abstract still-life to a quasi- (or actual) documentary journalistic style. The possibilities are endless.

There is a place for the pack shot within the broader genre of the product shot, and the relatively straightforward definition of it as a shot of a packaged commodity is not to denigrate the skill and expertise needed to carry off the shot effectively. But it is important to acknowledge that there is more to the product shot than the pack shot, and as there is much that can be done by way of pack shot, the possibilities for the product shot beyond this are immense.

Cameras, lenses and the studio

For large-scale advertising images, billboard posters and so on, the larger the size of the original, as a rule of thumb, the better. The nature of the product shot generally allows a slower pace of working (unless the product is a powerful sports car which might be an exception to the rule!) and allows the use of large format, i.e. 4x5 inch or above. Inherently these formats are more cumbersome, requiring ultra-heavyweight stands and tripods. Medium format such as 645cm through 6x9cm are an ideal compromise for quality of image and definition yet allowing a speedier working routine and a certain amount of manoeuvrability, even hand-holding, which is near impossible with the larger formats.

Another inherent factor with larger format is longer standard lenses and of course this in turn produces slower maximum relative apertures and creates a necessity for higher levels of illumination to achieve the depths of field that will often be required to hold an object in sharp focus.

Often the shoot will be a table-top set-up where smaller sized products are involved, but this does not mean that the studio for the shoot also only needs to be relatively small. It will often be the case that, small and tight though the table-top subject matter may be, the photographer needs to work with medium or large format cameras and long lenses at some surprisingly considerable distance from the table, and adequate space must be available for this mode of working. Small subjects can often need elaborate and large amounts of lighting equipment and for this reason too the studio must be of adequate size. In these situations, height is every bit as important as floor area.

Lighting equipment

Every product is different. It's an obvious thing to say, but the implications of it need to be absorbed when approaching a product shoot. The fact that every product is different means that every lighting set-up is going to have to be specific and individual to that product: it needs to be lit in the way that best suits it as an individual subject, and it is therefore difficult to generalise about the kit that is likely to be needed. The broad conclusion is that a large range of equipment should be to hand to cater for the many and varied specifics of any one shoot. Soft boxes large and small, standard heads, umbrellas, gobos, snoots, barn doors, reflectors varying in size from large panels down to tiny mirrors, bounce cards, torches, light brush, fibre optics, not to mention a range of rigging devices to hold some of these items... the list is seemingly endless, but the full range of items will come into their own under particular circumstances. At the very least, two or three standard heads, some bounces and perhaps an on-camera flash will be needed, but this basic list will only work for the most straightforward subject: it will not be adequate for the widely ranging variety of products that can crop up.

The vital elements when planning for an unusual product shoot are imagination and anticipation, but unfortunately these commodities are not available for purchase over any counter. Experience and a willingness to learn from experimentation and advice are perhaps the best methods for acquiring them. For many products, a certain amount of lateral thinking is required to find a way of lighting all its aspects in the most effective way, and the more obvious techniques may not be appropriate or practical. Good note-keeping is one practical method of ensuring that the results of experimentation and conclusions of experience will not be lost.

The team

The size of the team is often directly proportional to the size of the product, or it is possibly more accurate to say, to the complexity of the concept.

For example, shooting a simple box of matches will probably be a one-person job, whereas a more complex and large-scale such as a train delivering a crate or pallet-load of matches will entail a considerably more involved shoot requiring more electricians, assistants, and so on.

This is of course a very broad generalisation. At the opposite end of the continuum it is possible to argue that in some cases a very small-scale subject may require a disproportionate amount of specialist input: a dish of food may need a home economist, a stylist, a model-maker, prop buyers, and perhaps several assistants for the actual moment of the shoot to hold torches and mirrors to direct light onto exactly the right detail of the shot, to hand-hold gobs or fling water at the required moment, to mop it up again, set up and look after rigs, and so on.

As ever, the specifics of the shoot will dictate what crew are needed on the team. Where products need to look their very best and be presented in particular ways, there is no sense of stinting on the expertise of the right crew; a good stylist or set-dresser can make all the difference and their contribution and importance need to be recognised and acknowledged.

Product branding

In many areas of photography, the over-all look and feel of the shot is down to the photographer: the role of creative director overlaps with that of photographer especially where the work is personal or where the distinctive style of the photographer is a quality that is wanted for the final image. In the world of commercial product shots, however, this is not so likely to be the case. Most products already have a strongly branded image that has been defined by the client; an on-going thematic look or style of presentation, and the photographer may well be required to work within a very specific set of parameters that relate to this pre-existing branding. This may be either exciting or restricting to work with. Boundaries can be stimulus to the imagination; but if there is not scope for a creative interpretation, the best the photographer can do is to listen to the brief and do his best to realise it according to the specifications.

Different people work in different ways and some will find it more satisfying than others to work with a firmly branded product if this does lead to an ever-tighter brief. Needless to say, the extent to which the photographer delivers what has been requested will shape, in due course, what kind of commissions he is likely to pick up in the future, and specialisation may occur as a result either of conscious decision on the part of the photographer, or, as it were, by default, depending on client perception of results from past shots.

What can be particularly exciting is to have the opportunity to create a look from scratch which then becomes a major part of the branding of an item. Often a series of related shots, rather than one individual one, may be the brief, especially where a strong sense of continuity and connection is required between the range of images to establish branding. It is not uncommon nowadays for the stills photographer to be invited to go on to direct television and cinema commercials, which may seem unrelated, but of course the strength of the individual image is very much a part of both arenas. This can be a very lucrative as well as satisfying area to work in.

Working with the client

Of course 'product' means 'advertising' and with that advertising comes a creative team from an advertising agency whose concept the photographer has to realise. These people are the client and although the photographer is hired to produce the image, ultimately the client is the boss. The concept of team' is an important one to keep in mind. Even though it can sometimes feel as though the creative impulses of the client's art director and those of the creative photographer are pulling in opposite directions, it is necessary to create a sense of pulling together and give the shoot (and therefore the client) a good 'vibe' about what is happening.

The diplomatic and interpersonal skills of the photographer and his crew are often just as important as any technical skills.

As with any shoot, establishing the brief clearly beforehand is essential, and if everyone is sure of their role by the time of the shoot, conflict is likely to be minimised and the shoot has a good chance of running smoothly and effectively with everyone knowing what is expected of them.

Part of making the shoot a good event for the client comes down to the prosaic practicalities of offering good facilities such as hospitality, meeting space, use of office equipment and telephones and general comfort as well as adequate visibility during the shoot itself. For a large client team, it may be worth having a dedicated 'host' colleague looking after catering and hospitality and comfort so that the technical members of the team can concentrate on the job in hand.

BEER, WINES and SPIRITS

01

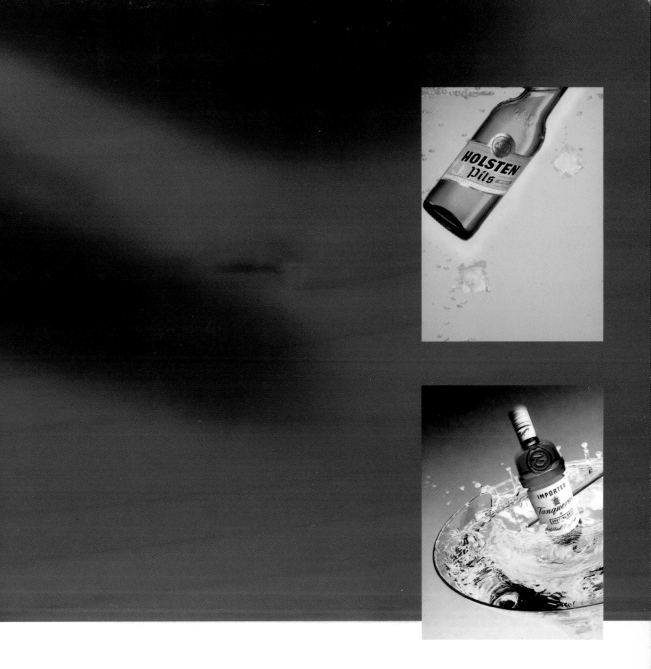

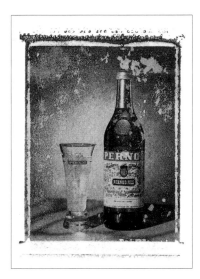

How can one photograph a flavour, an aroma, a sensation, or nutritious content? All these elements are vital in relation to experiencing a drink: coffee must have the rich, smooth taste we expect; wine has to have the right bouquet; whisky should leave the drinker with the warm tingle that comes from a good spirit; a health drink must taste fresh, nourishing and action-packed with vitamins. But in advertising these products cannot actually be sampled directly. There is only the look of the product to go on, and so the look must convey all of these non-visual qualities. There are ways of meeting this tall order, and the photographers in this chapter demonstrate a variety of the tricks of the trade. Warmth of flavour and sensation, aroma and a homey quality are all expertly conveyed by means of judicious use of props, setting, dressing and styling, and, of course, film stock and lighting. The heady flavours and aromas virtually float off the page in this chapter; and that is how it should be.

JOHNNY WALKER BLACK LABEL

photographer **Tony Hutchings**

client	Jones Hallet Design
use	world-wide advertising
assistant	Alice Culloden
art director	Andrew Jones
client	
personnel	Annie McCormick
	(Global Marketing)
camera	8x10 inch
lens	360mm
film	Fuji Provia 100
exposure	1/2 second at f/8
lighting	tungsten
props and	
background	orange paper surface,
	glass tumblers

This shot is simply and effectively achieved by the use of one tungsten spotlight and a mirror.

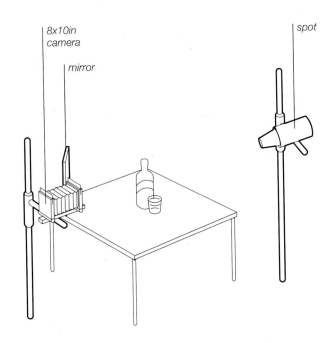

8x10in camera

mirror

spot

plan view

The spotlight illuminates the bottle and its contents from behind to ensure a warm glow to the whisky. The over-all orange hue can be attributed to the use of tungsten light with a daylight stock. The mirror to the left of camera and in front of the bottle directs back some of this light to define the label clearly, an all-important identifying element of the product. It also adds atmospheric highlights to the distinctively shaped shoulders of the bottle.

The second tumbler shadow in the far ground of the table top comes from a glass placed just out of camera view towards the spotlight.

key points

Sometimes the orange tone that tungsten creates with daylight film can be exactly what is needed for a particular product

Conversely, flash lighting on tungsten-balanced stock will give a cool blue hue

photographer's comment

This is an atmospheric picture to give a quality warm feel to a quality product.

Johnnie Walker and the striding figure device are registered trademarks of United Distillers and Vintners

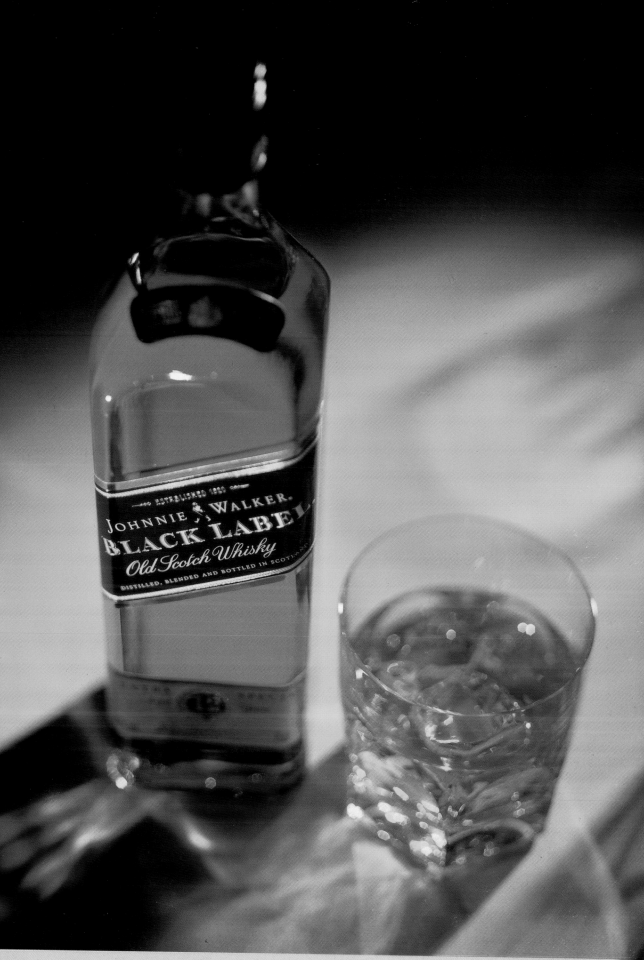

MOËT

photographer **Ben Lagunas and Alex Kuri**

use	personal work
assistants	Patrick, Isak, Jacob, Herb
art director	Ben Lagunas
camera	4x5 inch
lens	210mm
film	Kodak E100S
exposure	not recorded
lighting	electronic flash and light brush

Champagne is a subject with very romantic connotations, and here Ben Lagunas and Alex Kuri have chosen to portray this bottle of Moët in a low-light, romantic setting, complete with ice bucket and wine waiter's napkin, ready for a celebration to begin.

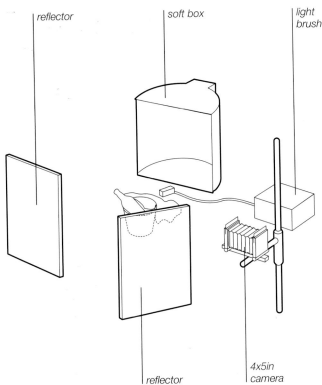

reflector soft box light brush

reflector 4x5in camera

plan view

key points

Balancing light brushing with other sources is a very skillful art

Spill light is as legitimate as source as any other if it is used deliberately to achieve the desired effect

The dim level of light for the shot is entirely deliberate in order to establish this intimate and romantic mood. The initial exposure involves a soft box to the left of the bottle and a white reflector the right of the camera. The light brush is then used to highlight areas of the napkin, which adds separation and gives more depth to the bottle. The shot has an over-all misty and mysterious look, achieved by spill and slight deliberate over-exposure from the light brush.

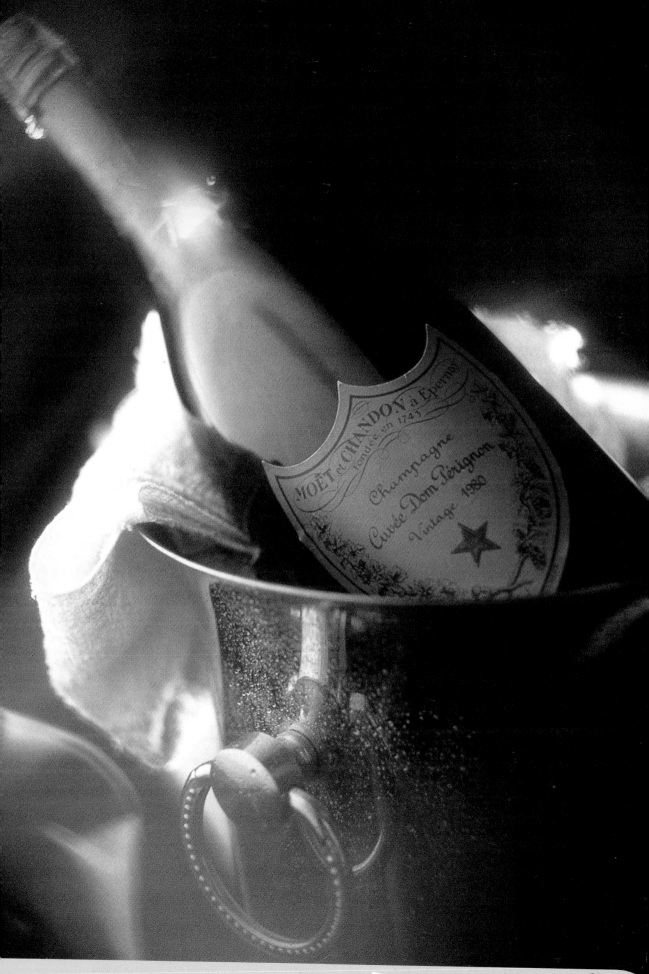

BEER, WINES and SPIRITS

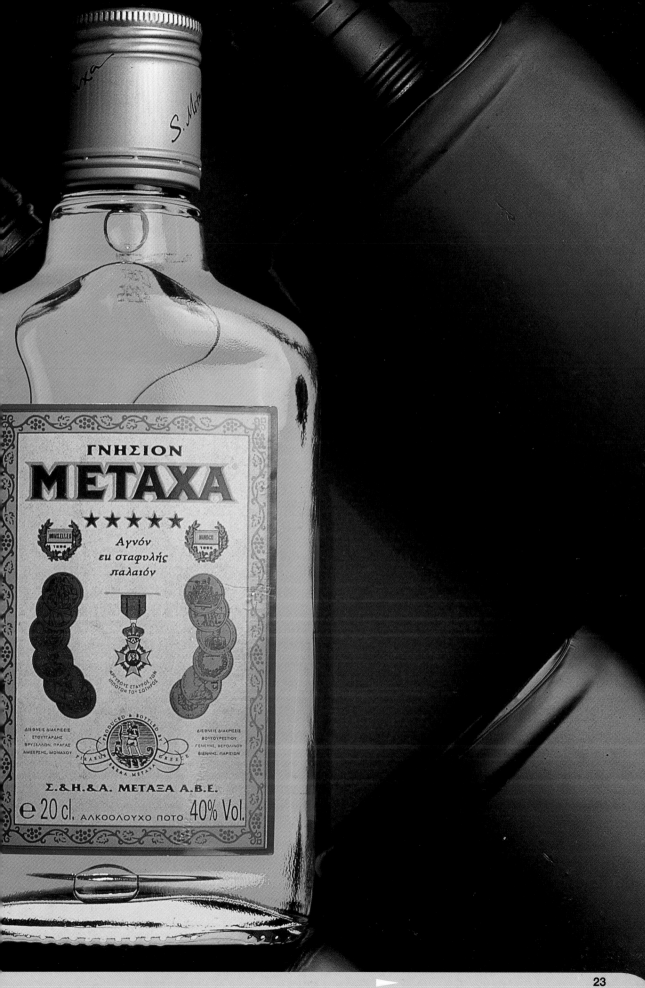

METAXA

photographer **Agelou Ioannis**

client	self-promotion
use	poster and studio promo material
assistant	Bouzoukou Antigone
stylist	Elen Tiriauides
camera	Mamiya RB67
lens	90mm
film	Fuji Velvia
exposure	1/30 second at f/8
lighting	Electronic flash
props and background	identical bottles emptied and painted black with matt spray, black paper, perspex, glass, orange gel in strobe underneath bottle

A well-considered shot, skillfully executed, can bring a whole new dimension to an otherwise straightforward subject, as evident in this striking example.

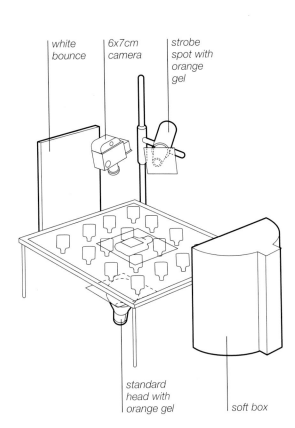

white bounce

6x7cm camera

strobe spot with orange gel

standard head with orange gel

soft box

plan view

key points

Polaroid tests are helpful to establish the correct exposure and contrast ratio

It is important not to exceed the film's latitude and lose the shadow detail

There is a bare bulb flash head with an orange gel under the bottle. The table has an area cut-out of white perspex beneath the bottle, flagged by a black mask cut-out the same shape as the bottle but slightly smaller. This allows light to shine from below, without any spill light interfering with the other areas of the shot.

The white perspex diffuses the light evenly across the bottle, acting as a backlight inasmuch as it is directly opposite the camera, itself directly above the bottle. A tightly snooted standard head illuminates the label of the bottle from the front. The rest of the image is lit by a large soft box to the right and above which models the black background bottles, and fill light is provided by a white bounce card opposite the soft box. The perfect bubble in the centre of the neck of the bottle is the finishing touch.

photographer's comment

We tried several different bottle formations. We really liked this juxtaposition. A mental exercise was avoiding exceeding the emulsion's exposure latitude.

TANQUERAY GIN

photographer **Tony Hutchings**

client	Leo Burnett - Puerto Rico
use	posters
assistant	Alice Culloden
art director	Francisco Fernandez
camera	6x9cm plus 35mm
lens	150mm plus 20mm
film	Fuji Ptrovia 100
exposure	1/60 second at f/11
lighting	electronic flash

There are two component parts to this image. The first is water dropping into the glass with a cocktail stick in it. The second is the gin bottle itself.

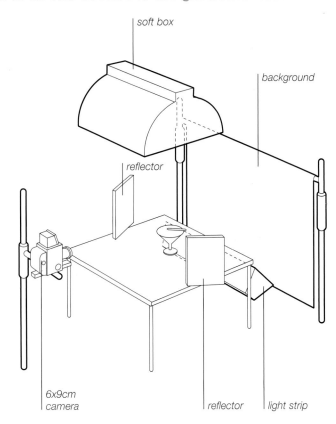

soft box

background

reflector

6x9cm
camera

reflector

light strip

plan view

key points

When creating a composite of two separate images it is important that the lighting is appropriate to both components

Be very careful when working with water and electronic flash equipment

The 6x9cm camera was used with the 150mm lens to photograph the glass of water. Drops of water were splashed into it from above. The imprecise nature of the "perfect" splash meant shooting around 70 frames to be sure of capturing the ideal shot. A strip light illuminates the white background. A large soft box about a metre above the table lights the glass and a white reflector on either side of the glass illuminates the under side.

For the gin bottle element, a 35mm camera was used with the 20mm wide-angle lens to distort the bottle. The two shots were put together electronically to create this stunning final image.

photographer's comment

This image was art-directed remotely from Puerto Rico using the World Wide Web! Various stages were shown for approval before sending the final image.

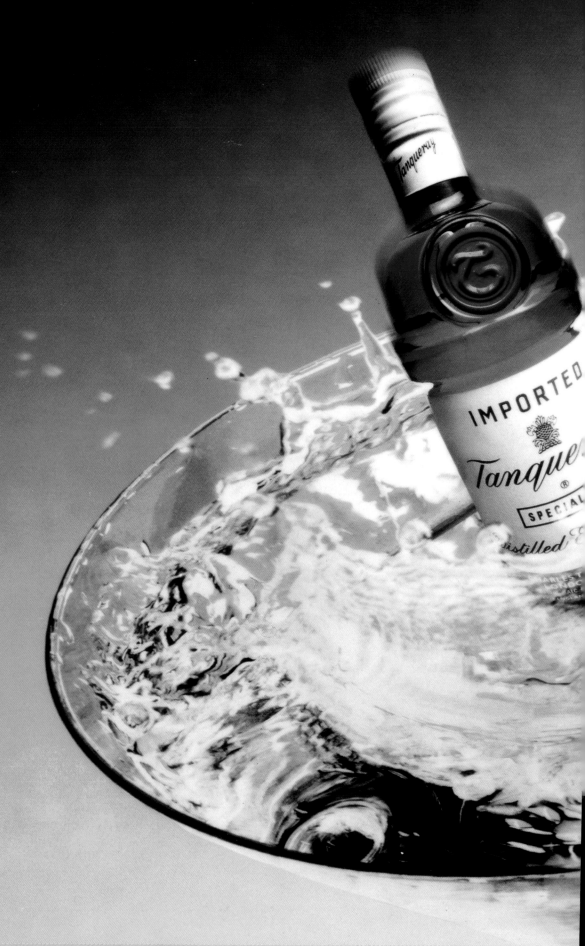

BEER, WINES and SPIRITS

WHISKEY

photographer **Peter Millard**

use	promotional
client	URM Distillers
camera	6x7 cm
lens	127mm
film	Fuji 64T
exposure	not recorded
lighting	tungsten
props and	
background	water-colour paper

The interesting play of light and colour in this shot is the result of simple yet effective "special tricks", as photographer Peter Millard explains.

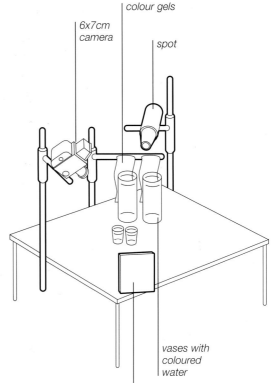

colour gels

6x7cm camera

spot

vases with coloured water

reflector

plan view

key points

Sometimes the props that are out of shot are just as important as those in centre frame

Techniques and tools for positioning flags and bounces are very important to the advertising photographer

"The shot was taken from directly overhead as the whole purpose of the shot was this warm, rosy, glowing shadow coming from the whiskey glasses. Plastic ice was used and the background for this shot was simply water-colour paper. The extra colour was created by filling glass vases of various shapes and profiles with coloured water and letting the light from a one kilowatt tungsten spotlight shine through both them and some coloured lighting gels. The shot was closely art-directed by the Creative Director of the agency handling the promotion and the crop was intended to be very tight on the glasses with plenty of space around and below for the text."

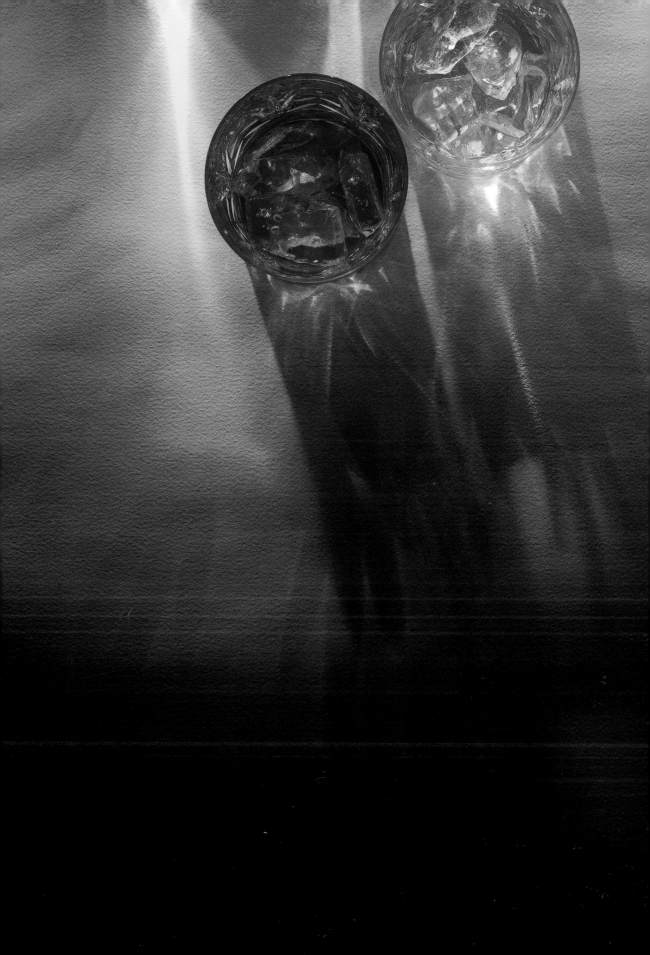

HOLSTEN PILS

photographer **Martin Wonnacott**

client	Scottish Courage
use	posters
assistant	Darrell Russell
art director	Marcos Quinn
camera	4x5 inch
lens	210mm
film	Kodak EPP 100
exposure	f/16
lighting	electronic flash, light brush
props and	
background	custom-made water tank

"We built up the shot by lighting each element separately," says Martin Wonnacott. "For example, the bubbles and background were lit together, the bottle and ice were lit together, and the label separately. The glow behind the bottle was achieved with the lighting hose at a separate exposure to the rest of the shot."

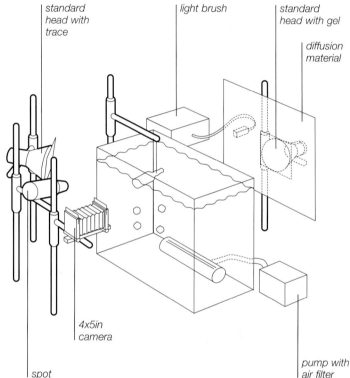

standard head with trace

light brush

standard head with gel

diffusion material

4x5in camera

spot

pump with air filter

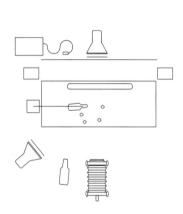

plan view

key points

It is always useful to have to hand a variety of clamps and tools for positioning props: take an imaginative look round the local hardware store for an endless range of practical possibilities

Plastic ice is an invaluable prop when working under the heat of studio lights

In a clever display of legerdemain, the beer bottle is suspended in the water tank, held in a fixed position by means of a clamp, and the ice is positioned as required. A pump and air filter in the tank produce the bubbles to order.

A three kilowatt head shoots through a yellow gel and through a large trace screen which forms the background to the image. A spot light to camera left illuminates the all-important branded label, while a standard head further round to the left again, shoots through a trace screen to pick up the shape and model the bottle. Finally a separate exposure is made, using the light brush from behind the background trace screen and yellow gel to produce the peripheral ghostly rim light and to trans-illuminate the bottle.

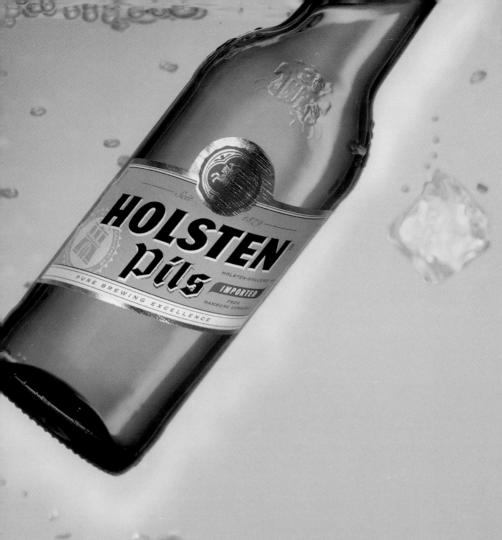

JOHNNIE WALKER RED LABEL

photographer **Martin Wonnacott**

client	United Distillers
use	posters
assistant	Darrell Russell
camera	4x5 inch
lens	72mm
film	Kodak E100 SW
exposure	10 seconds at f/8
lighting	electronic flash, tungsten
props and background	gold reflector

The quintessential quality of warmth associated with a good whisky was an essential quality for this product shot, and was captured in this rich and glowing shot by expert choice of stock and lighting.

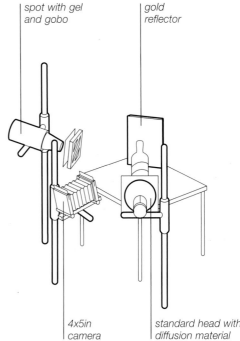

spot with gel and gobo

gold reflector

4x5in camera

standard head with diffusion material

plan view

key points

For a warm look, use a warm lighting set-up

The characteristic orange tinge of tungsten when used with daylight-balanced film may be exactly what the job requires

The Kodak E100 SW stock is of itself a warm-toned film; the tungsten spot has a golden edge to it when used with a daylight-balanced film, and the use of gold reflector-cum-background as well as a warm-up filter on the lens are the finishing touches to a set-up designed for a heady glow.

The camera, which has an 81EF filter on it, looks up at the bottle which is placed against a large gold card. A standard head placed to the right of the camera shoots through a trace screen. This illuminates the label and highlights the right hand side of the bottle. To the left of the camera the tungsten spot light is modified by warming gels and a gobo which introduces elements of light and shade and "shape" to the light.

Finally, a smaller gold card is placed directly behind the bottle to reflect light from both sources and this results in the central yellow gleam below the label.

photographer's comment

We wanted to break from tradition for a bottle shot by using a wide-angle lens and extreme angles.

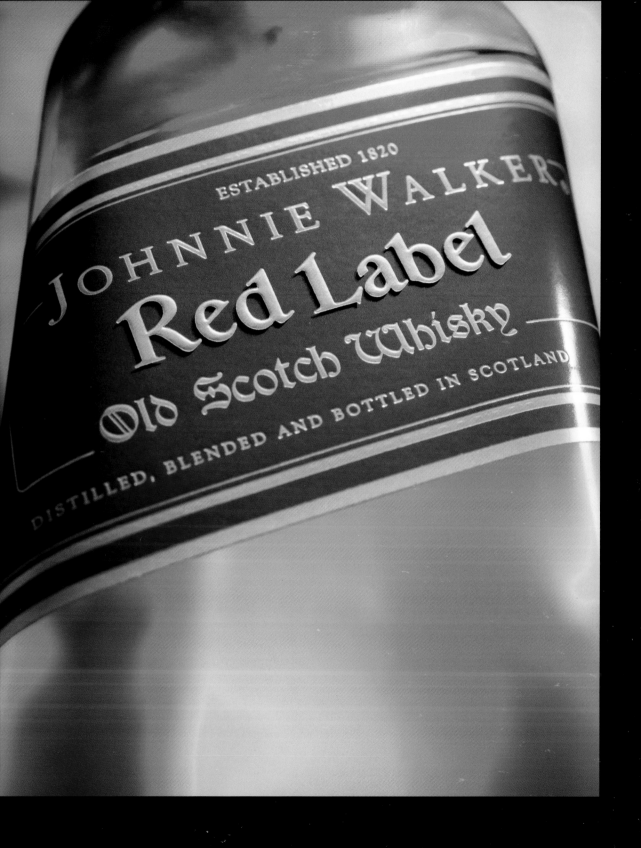

PERNOD

photographer **Peter Millard**

client	Pernod
use	advertising
camera	4x5 inch
lens	240mm
film	Polaroid type 59
exposure	not recorded
lighting	tungsten
props and background	twigs

"The shot came from a Pernod job that I shot commercially, after which I had a play with the basic bottle and glass scenario," says Peter Millard.

spot 4x5in camera background soft box

plan view

key points

When lighting from behind, take care to avoid flare in the lens which may appear as a milky cast

Images originated on delicate image transfer need to be re-shot onto transparency for the sake of durability

"I had played with Polaroid's image transfer process for some time and through experimentation had managed to make it a little more predictable. I thought this product (rustic French) was particularly suited to the process, and shot the bottle and glass on a simple round café style table, lit with a tungsten spot to help with the daylight effect, and a few dappled shadows from some twigs in the foreground."

The background is a large tracing paper screen illuminated from behind by a 500 watt spot light which is flooded to produce a glow. The bottle and glass are lit with a one kilowatt tungsten lamp to the left of camera.

The twigs are placed quite close to the bottle and glass and close to the surface that they are standing on so that the shadows that are cast are reasonably hard.

photographer's comment

Once the image transfer was completed, the selected image was distressed a little further, then re-photographed, again with tungsten lights to keep the texture of the card from the transfer onto transparency film.

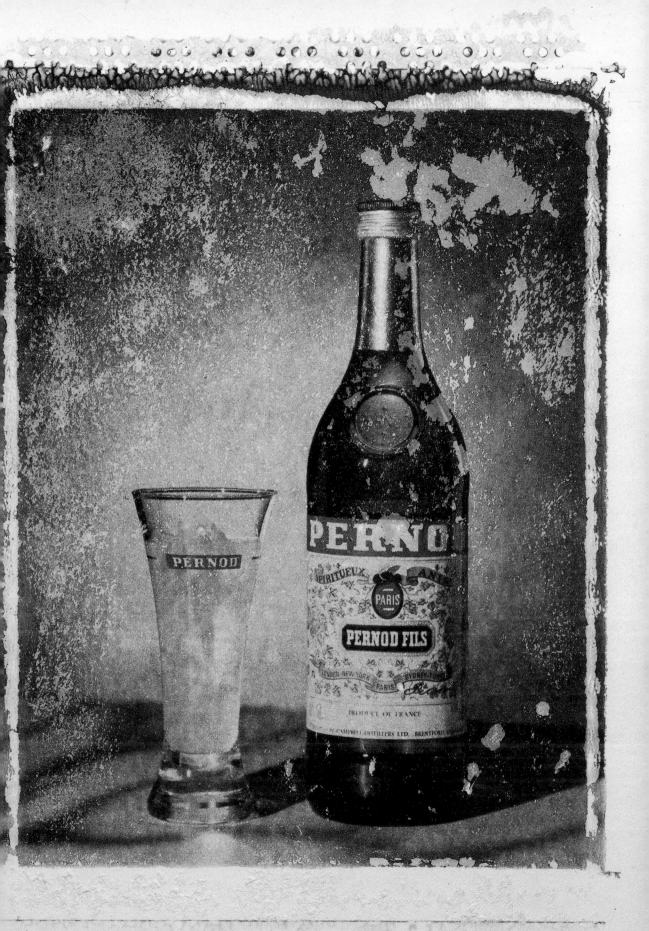

▶ BEER, WINES and SPIRITS

OVER THE TOP

photographer **Peter Millard**

use	personal work
camera	4x5 inch
lens	240mm
film	Fuji 64T
exposure	not recorded
lighting	tungsten
props and	
background	tabletop and glass

"This shot was taken for my portfolio," says Peter Millard. **"But I had a particular agency in mind (they had a lot of beer accounts)."**

plan view

key points

If a prop is available for only a limited time, take the opportunity while you can to photograph them for stock or reference shots which may be combined with other projects later

The power of suggestion by using shadows and light can be just as powerful as an explicit high-key hero product

"The shot was taken from directly overhead as I wanted the shape of the glass and bottles to be described by the shadows they cast. The background was a nicely grained pine tabletop from a professional background company (Table Props) which I happened to have in my studio from another job. The glass was filled with ordinary beer and the beer head created by mixing a little beer with lemonade and clear washing-up liquid, then frothed up with a baster (a plastic tube topped by a rubber bulb, used for basting when cooking) and carefully spooned into the glass to make a good shape.

"The shot was lit by a single one kilowatt spot, flooded slightly to give crisper shadows and a piece of card was used to shadow down the top right hand corner, just to emphasise the shape of the glass a little."

photographer's comment

Oh yeah! The agency I had in mind when I shot this, hated the picture – can't win them all!

ICE BUCKET

photographer **Martin Wonnacott**

client	Scottish Courage
use	posters
assistant	Darrell Russell
art director	Marcos Quinn
camera	4x5 inch
lens	150mm
film	Kodak EPP 100
exposure	f/16
lighting	electronic flash
props and	
background	six foot square
	custom-made water tank

"The weight of a full water tank of this size was of great concern during the shoot because at any time we could have flooded the studio, therefore safety was paramount and all electrical items were raised off the floor," comments photographer Martin Wonnacott.

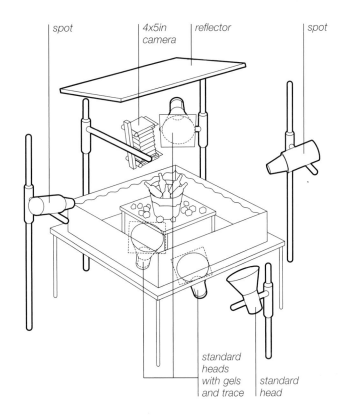

spot · 4x5in camera · reflector · spot

standard heads with gels and trace · standard head

plan view

key points

Working with water and electricity under any circumstances is a safety issue; where the water is in a raised tank, its weight and security is also a major consideration

It is important to minimise the number of variables in a shoot to ensure the desired composition and lighting are achieved

The tank was under-lit by two flash heads and various blue gels and trace over them. The bottles were lit from below and from spot lights to the sides.

Everything we see in this shot is really there; there are no special after-effects or manipulations. The plastic ice cubes were glued into position to maintain full control of the composition. To achieve the subtle ripple on the surface, an 8x4 foot white polystyrene board was suspended overhead and lit from below to gently put highlights on the white ripples on the surface of the water. Adding to the texture in the water is a rippled perspex sheet below the ice bucket.

photographer's comment

Changing the water alone took two and a half hours which had to be done several times during the shoot. The final image was achieved through the camera.

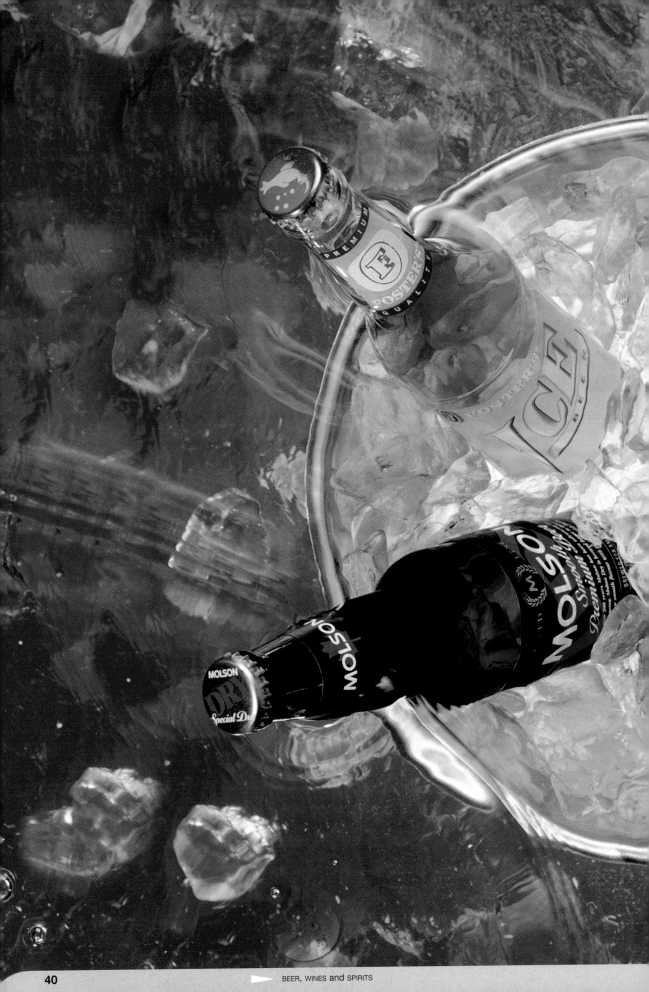

BEER, WINES and SPIRITS

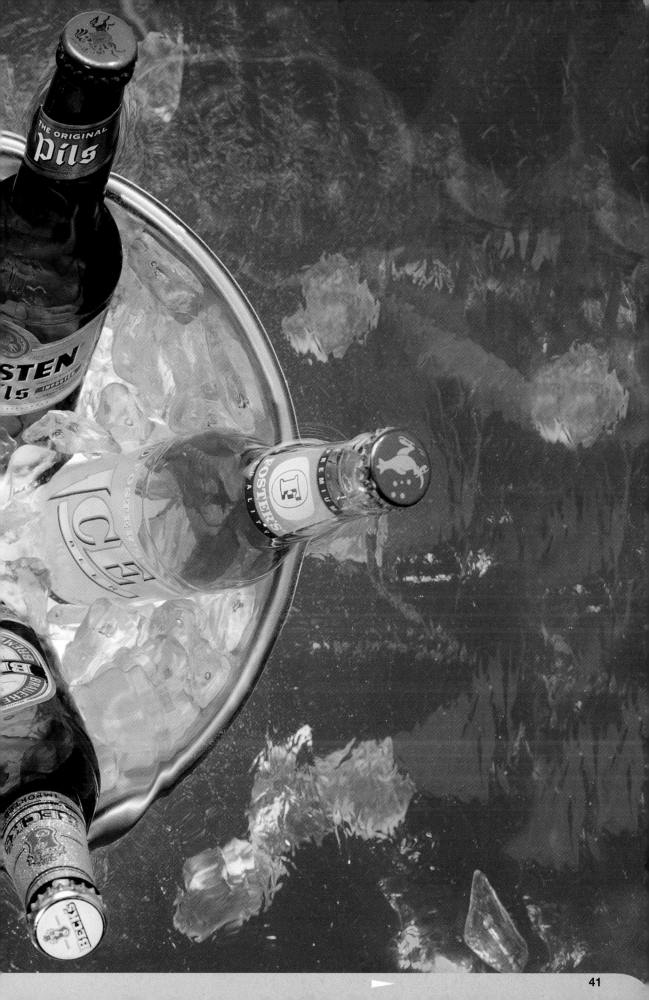

COSMETICS, JEWELLERY

02

JEWELLERY

and PERFUME

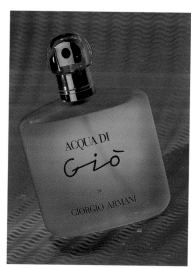

The products featured in this chapter are more than simple forms of adornment; they represent a lifestyle the advertiser wants the consumer to associate with the product. For this reason, context and setting are extremely important. In some cases, unique packaging is sufficient to suggest the cool uncomplicated business of owning and using the product, as in Peter Millard's "Necklace", for example. In others, the concept may be quite sophisticated and subtle, but the allusions created are very important to the marketing image of the product. A good example of this is Jörgen Ahlström's "The Smell of New York". There are also some particular technical problems that recur when shooting jewellery and cosmetic products. The fact that these products are likely to involve shiny surfaces, whether precious metals, stones, or glass or plastic packaging, is an important factor to consider. Some of the many ways of dealing with these potentially tricky surfaces are demonstrated in this chapter.

AQUA DI GIO

photographer **Chet Frohlich**

use	self-promotion
camera	4x5 inch
lens	210mm
film	Fuji Provia 100
exposure	f/16
lighting	electronic flash
props and background	white textured paper

The perfume was essentially lit with a small spot reflecting on a silver card behind the bottle. A small piece of green gel was placed over the card to dramatise the already green coloured liquid.

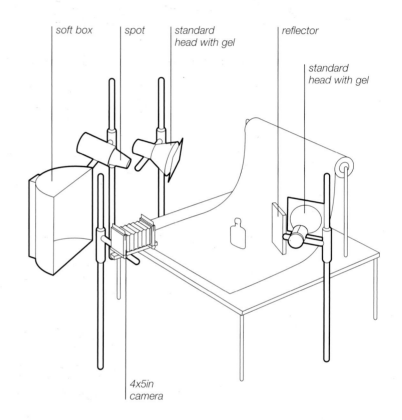

soft box spot standard head with gel reflector

standard head with gel

4x5in camera

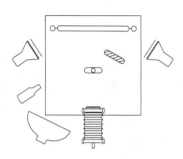

plan view

key points

Emphasising the colour of a liquid by extra coloured gels can dramatically improve a shot

White light can be used to dilute or reduce the intensity of a colour cast if it is necessary to do so

Since the background was white, it was important that very little white light be allowed to hit anywhere except the card, since it would otherwise wash out the colour placed on the background with the gels. A 20x24 inch light bank was used in front of the bottle and very low intensity to place the specular highlight on the spray nozzle.

The background was lit with two opposing standard heads with spot grids and gels (magenta and blue). The texture of the paper and shadow of the product create colour shifts and interests in the background. The camera was tilted slightly to create dramatic impact.

photographer's comment

The Aqua de Gio photograph was created as a self-promotional piece with three main goals in mind: first, to create a visually strong image that stands alone simply on colour, impact and beauty; second, to show off my technical skills and abilities as a photographer; and third, to show a particular type of product.

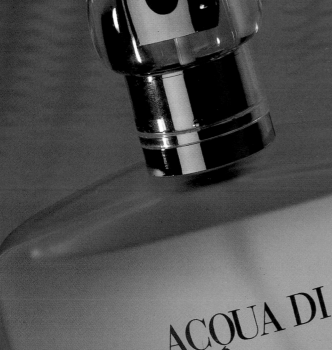

COSMETIC

photographer **Ben Lagunas and Alex Kuri**

assistant	Patrick, Izak, Jacob, Herb
art director	Ben Lagunas
camera	4x5 inch
lens	210mm
film	E100S
exposure	f/16
lighting	tungsten and light brush

The use of tungsten combined with a light brush indicates that the shutter was opened at least twice for this shot, but the "ghosting" evident around the cotton buds in the foreground is evidence of yet another exposure, used to capture a slight amount of movement and add interest to the composition.

plan view

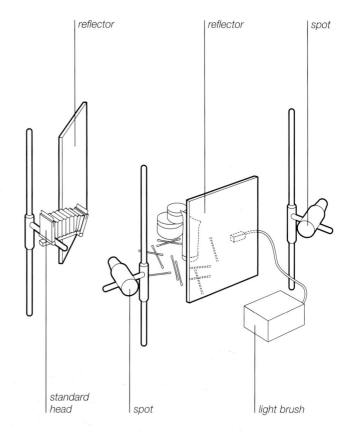

key points

A still life product shot can be given an extra dimension by introducing the element of movement

It is important to know how different film stocks behave when making long exposures during light brushing as reciprocity failure may occur introducing unwanted colour shifts

The product is lit essentially from the camera left by light that is reflected off a large white bounce on that side; the light originating from the tungsten spot to camera right. A black panel to the right enhances the fall-off on the right side of the subject and also flags the product from any spill light from the tungsten spot. The background is lit by a second spot aimed at from the right.

The light brush was then used to pick out areas of the product labels, giving the clear bright pools of light across selected areas of the individual cosmetic packs.

photographer's comment

The picture had an extra exposure (one second) to produce the sensation of movement.

ARTISTRY*
REVITALISING
NIGHT TREATMENT
CREME DE NUIT REVITALISANTE
MADE IN U.S.A.
NET: 75 ml

ARTISTRY*
NORMAL-TO-DRY-SKIN
MOISTURE RICH CLEANSER
NORMALE-SECHE-TENDANCE SECHE
CREME DEMAQUILLANTE HYDRA
MADE IN U.S.A.
NET: 125 ml

ARTISTRY*
GEL
EYE MAKE-UP
REMOVER
GEL
DEMAQUILLANT
POUR LES YEUX
MADE IN U.S.A.
NET: 30 ml .25 f

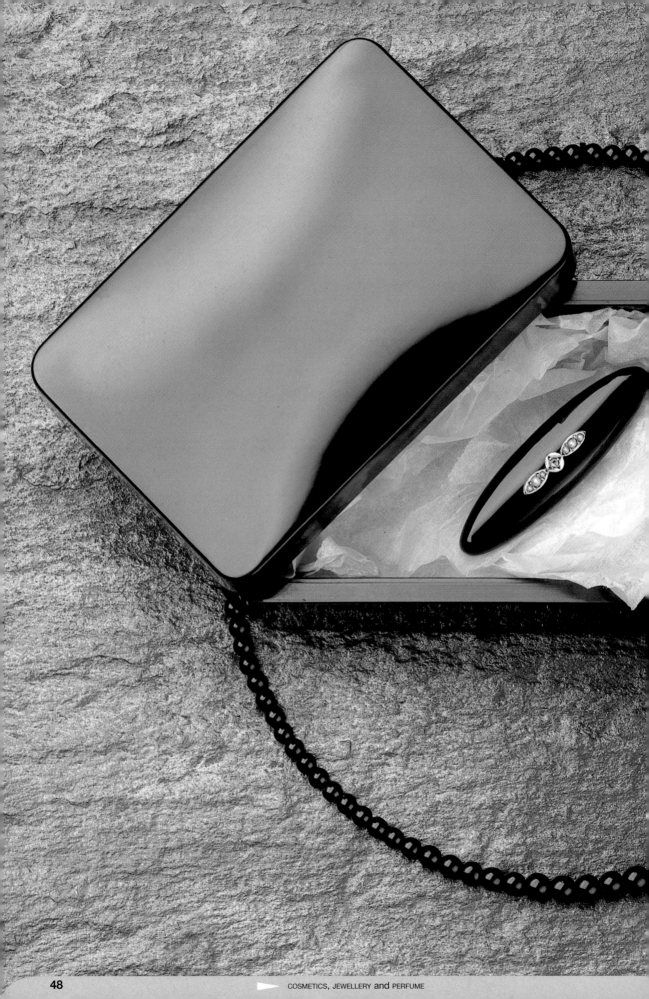

► COSMETICS, JEWELLERY and PERFUME

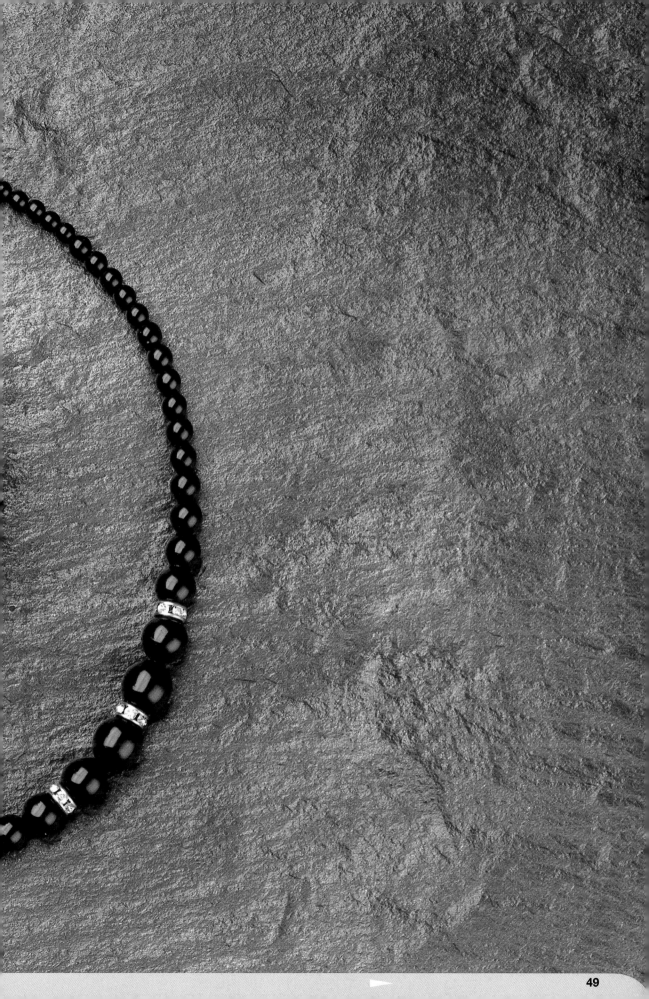

NECKLACE

photographer **Peter Millard**

client	personal work
use	portfolio
camera	8x10 inch
lens	480mm
film	Kodak 6117
exposure	f/64
lighting	electronic flash
props and	
background	slate, oil to give a good sheen

A one metre square Elinchrom soft box at full power is placed at very close proximity at roughly 45 degrees to the subject.

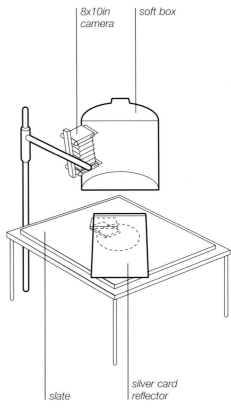

8x10in camera

soft box

slate

silver card reflector

plan view

key points

Depth of field is dependent on the focal length of the lens and the proximity of the camera to the subject being photographed

To allow for a smaller aperture, thus creating greater depth of field, multiple flashes can be utilised

Opposite this is a silver reflector card to provide fill light from the other side. There are four discrete flash pulses because of the use of this long lens at close proximity giving a shallow depth of field.

The even sheen in the box defines its shape, and similarly on the brooch the reflections of the soft box and fill card provide modelling that gives a clear impression of the three-dimensional shape and curvature.

On the necklace this effect is particularly noticeable in the larger beads, where two separate reflections are clearly visible. The tissue paper inside the box is shaded on the upper left by the lid, giving a low key background against which the high key side of the brooch rests. Conversely, the lower right area of tissue paper is high key and the corresponding side of the brooch above it is low key, giving a good sense of balance to the composition.

photographer's comment

The camera was positioned directly over the necklace to minimise distortion of the circle. I left plenty of bleed around the image to play with it later on.

88 SOAPS

photographer **Alan Randall**

client	88 Soaps
use	advertising
camera	4x5inch
lens	150mm
film	Ektachrome 64
exposure	1/60 second at f/16
lighting	electronic flash
props and	
background	wrapping paper

When a whole family of products is available, it can be very appropriate to photograph them together in a group portrait.

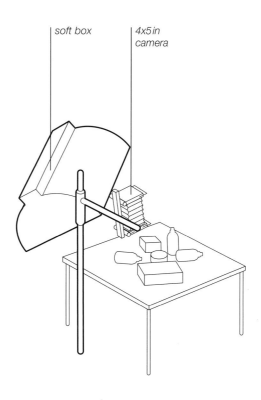

soft box 4x5in camera

plan view

key points

Lighting should complement the product's design to effectively maximise impact on the viewer

Detail in shadow areas is important and can be brought out by using the largest format available

In this shot, this basic idea is taken a step further by using the wrapping paper available in the range, which is decorated in a complementary fashion, to be the backdrop. How the lighting is executed is quite clear from the shadows. A large soft box is positioned directly over the tabletop, resulting in shallow, short shadows, which provide excellent modelling for the products. The relatively flat lighting is fine for this shot, as enough contrast is provided by the textures and shades inherent in the design of the packaging.

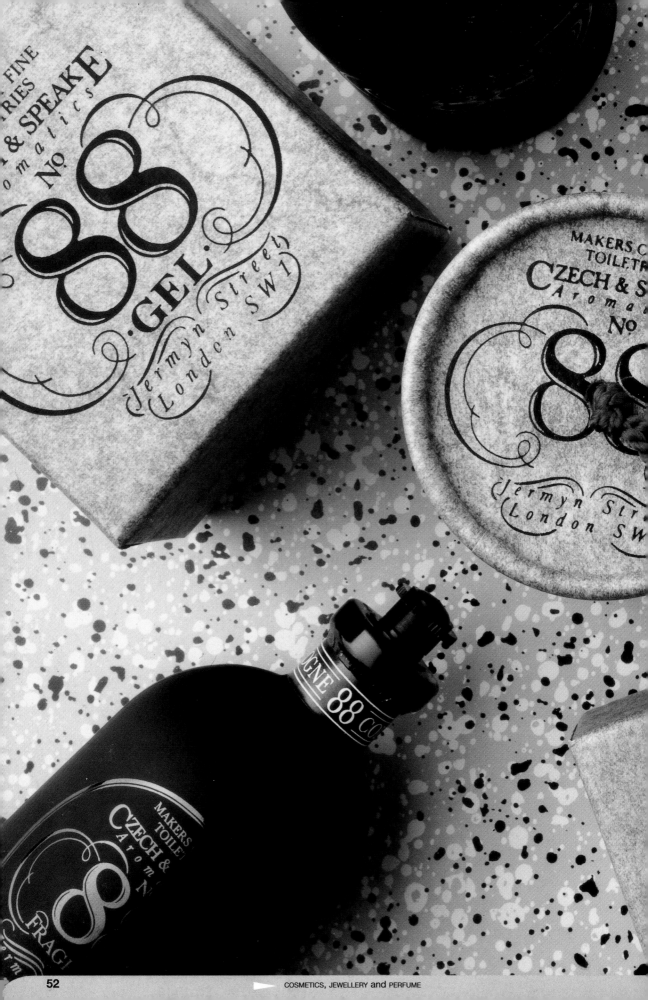

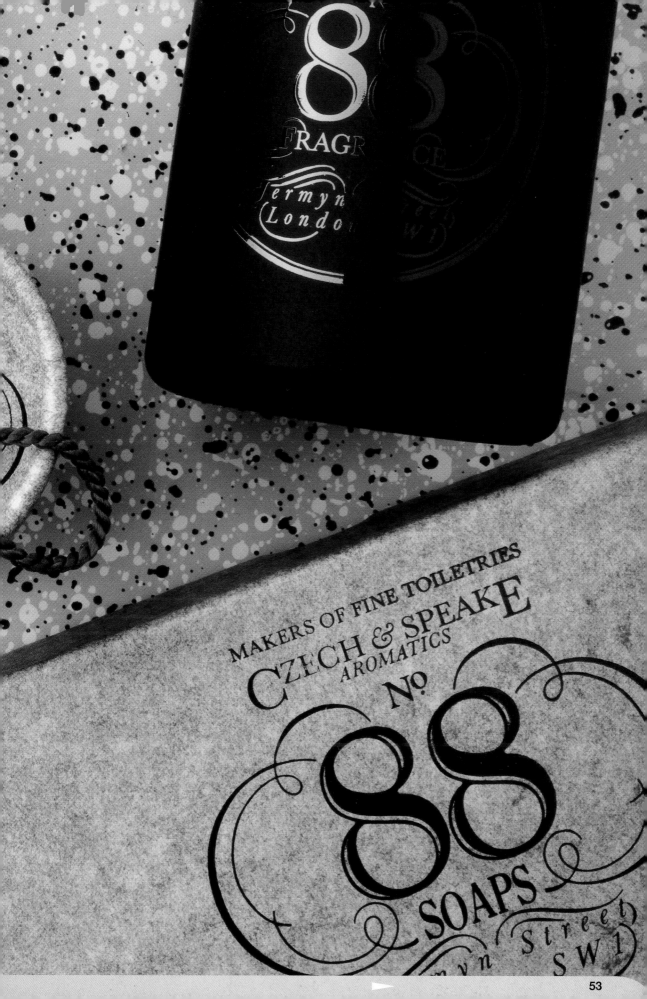

THE SMELL OF NEW YORK

photographer **Jörgen Ahlström**

client	Zest
use	editorial
camera	4x5 inch
lens	47mm
film	Kodak GPH 100
exposure	not recorded
lighting	electronic flash

Unlikely as it may seem, this shot is lit from behind and beneath only, and with a single standard head.

4x5in camera

background

standard head

plan view

key points

Back-lighting is a very practical method of avoiding undesirable speculars, reflections and shadows

Bracketing when using colour negative stock is not as essential as for transparency stock - however briefing the printer is so the desired result is achieved

The products are placed on a silk cove that curves away seamlessly behind and below them, and the light placed under this is diffused evenly and shines up and through the bottles.

The light on the cube bottle tops in particular demonstrates this set-up: the brightest facets are those facing the light source on the lower right; next most bright are the frontal faces as light bounces back from the foreground white area; and least illuminated are the uppermost faces, which are not directly lit at all. The same pattern of light distribution is evident on the model cars quite clearly.

The shiny surfaces of the bottles and the coloured liquids within act as reflectors and filters on other areas of the subject. Notice the reflection of the Elizabeth Arden bottle lid in the Gucci Envy bottle top behind it, and see how the colour of the eau de toilette at back right contributes the deeper area of colour in the verticals of the bottles at the front.

photographer's comment

The concept was New York skyscrapers represented by the perfume bottles with the traffic below.

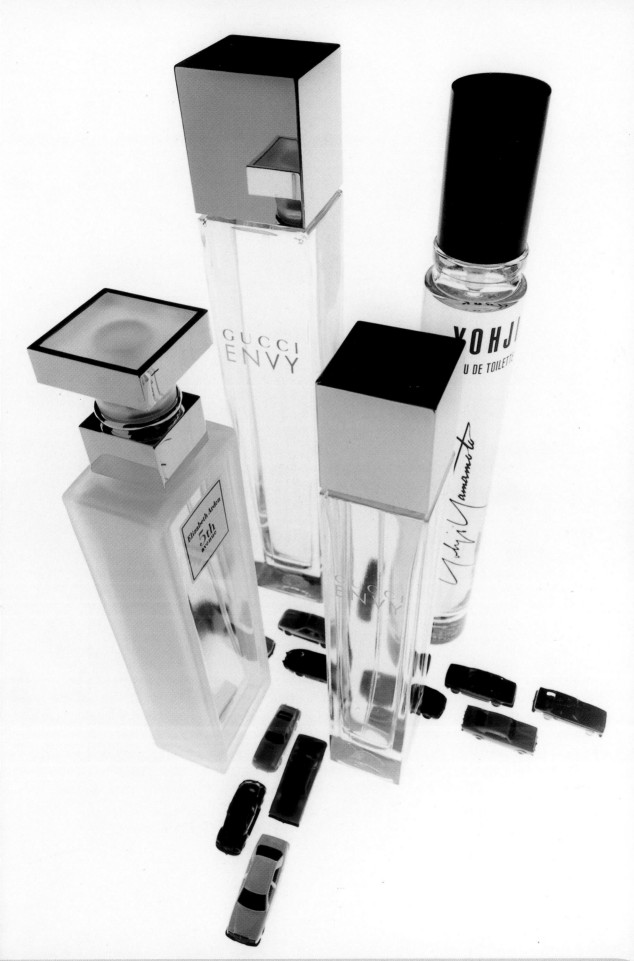

"PHOTO"

photographer **Agelou Ioannis**

client	men's fragrance shop
use	promo posters, mailer
assistant	Mario Archontis
art director	Maria Alexandris
camera	6x7cm
lens	180mm
film	Fuji Velvia
exposure	1/60 second at f/11
lighting	electronic flash
props and background	red basin, hanging rope, clips, colour background

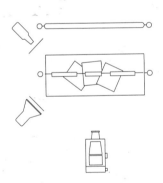

plan view

key points

Don't automatically assume that how the eye perceives a scene is how the film stock will record the scene.

Polaroid tests are a quick and simple way of measuring exposure and producing a good colour rough

Sometimes a title can be a stimulus in an unexpected direction as a brief for a shot.

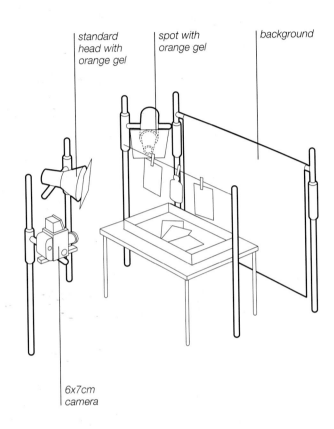

standard head with orange gel

spot with orange gel

background

6x7cm camera

When Agelou Ioannis thought about the word 'Photo' which was the title for this commission, he wanted to come up with something unusual and eye-catching.

"Experimenting with 'Photo' as a word, we opted for a visual interpretation," he says. " 'Photo' was hung among two reversed digitally manipulated and printed photos of the product itself, above a few more expecting their turn in the sink, drying in the darkroom. The water drop at the bottom right corner had to be transparent and only one. Orange gels placed in front of the light conveyed a warm darkroom feelings. Red ones were too much. The client is an amateur photographer himself although we didn't know it! His comment was: 'Great! I couldn't do it better myself!'"

photographer's comment

I greatly enjoy brand name visual interpretation. It's always a challenge that can lead to unexpected images.

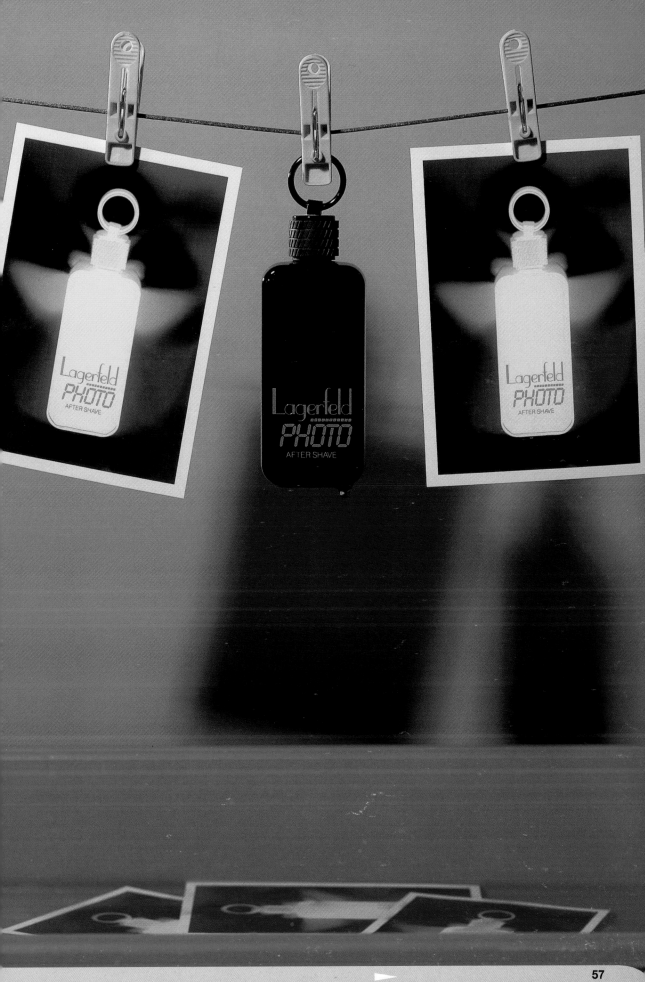

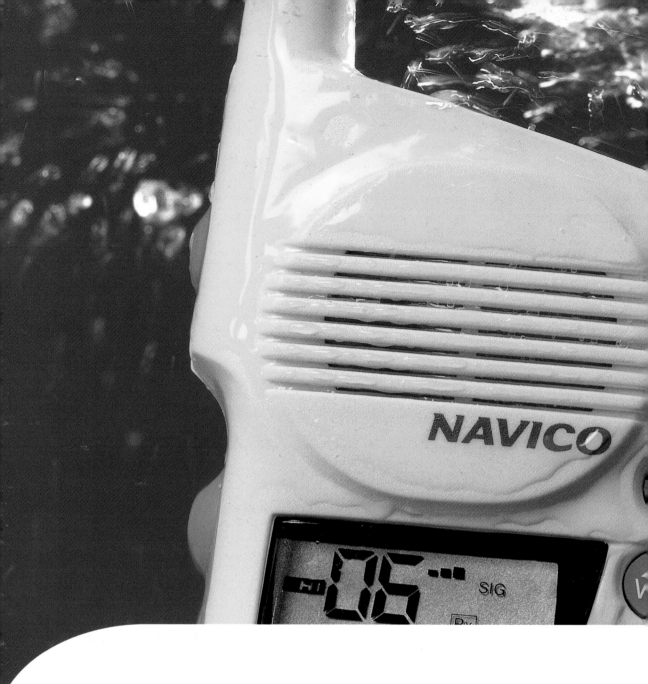

ELECTRONIC

PRODUCTS

03

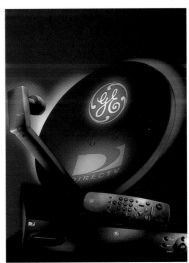

It is no surprise that a common interpretation for products within this category is to emphasise the sleek, slim-line designer look of the last word in sophisticated new gadgetry. Yet this is not all there is to be said on the subject. Surrealism has its place for these products, as well as a more conventional in situ approach. The applications and uses of electronic devices are so many and varied that the styles appropriate for promoting them also have to meet a range of criteria: for some, the futuristic look will emphasise the modernity and cutting-edge of technology quality; for others, a friendly product in a familiar home or office situation will be the brief in order not to scare potential consumers with science, but to make the technology look approachable and manageable within a domestic or working context. People can have extreme reactions for or against products of this kind, and the aim of these product shots is to appeal to these diverse and specific areas of the market in a very specific way.

COLOUR MONITOR

photographer **Agelou Ioannis**

client	computer hardware distribution company
use	editorial
art director	Ioannoy Dimitris
camera	RB67
lens	50mm
film	Fuji Velvia
exposure	1/30 second at f/4.5
lighting	electronic flash
props and background	red, green and blue coloured paper

One small soft box with barn doors (so that the light would not spill on the monitor) lit the coloured papers only left and above of the monitor.

spot

soft box with barn doors

green paper

red paper

6x7cm camera

blue paper

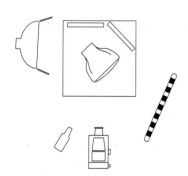

plan view

key points

When multiple exposures are used remember that the sum of the two exposures needs to add up to the correct final exposure

Snoots are far more precise than barn doors, however barn doors can give a hard line

Very close to this soft box was a standard flash head with a very narrow snoot, in order to light only the logo. The camera itself was positioned lower than the snoot.

A maximum aperture on the 50mm lens of f/4.5 was used to attain a minimal depth of field so that the edges of the monitor were allowed to blur and go out of focus. This shot required two exposures: the first one was for the background, using a soft box with the snooted head turned off and with three diffusion filters in front of the lens.

For the second exposure, the background soft box was off, the snooted head was on, and no filters were used over the lens.

photographer's comment

The paper colours selected echo those of the monitor logo. We only wanted to promote the logo and have a subtle impact using the RGB colours.

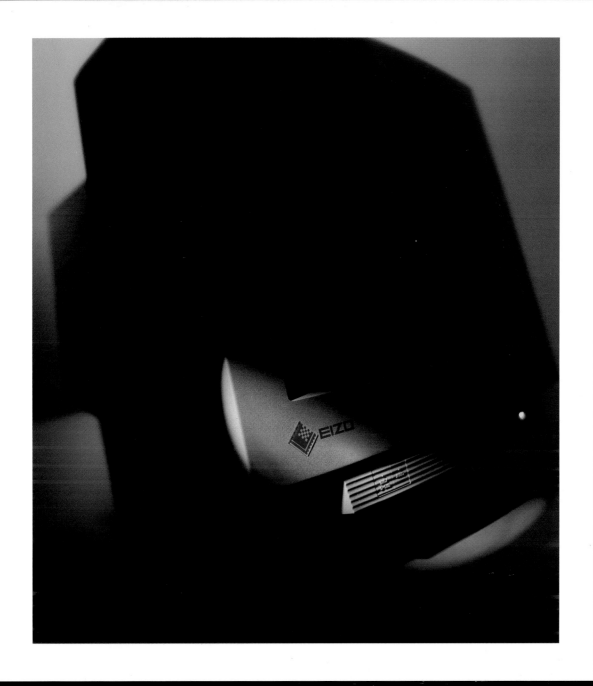

ANTENNA

photographer **Ricardo de Vicq de Cumptich**

client	General Electric
use	advertising
assistant	Ednaldo de Sousa Ramos
art director	Luis Christello,
	Javier Talavera
agency	F.J. Comunica o Total
camera	4x5 inch
lens	210mm
film	E100S
exposure	not recorded
lighting	electronic flash, light brush
background	white paper

This moody shot shows to good effect a look that can be achieved by judicious use of the light brush. The pearly glow is a characteristic quality of this form of lighting.

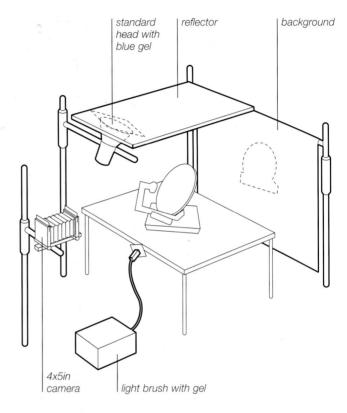

standard head with blue gel

reflector

background

4x5in camera

light brush with gel

plan view

key points

It is worth remembering that a light brush, as any other source, can be modified by gels to change the colour of the light

When making multiple exposures remember that the sum of the individual exposures will make for the whole exposure

For the initial exposure, a standard head with a flash gun was used, 2.5 stops underexposed and shooting up into a polyboard above the set.

What is particularly interesting here, though, is the technique used for the light brush work. Ricardo de Vicq de Cumptich placed the satellite dish and receiver against white paper background, put a light in place of the camera, lit the objects from there to throw shadows onto the white paper behind and traced the shadows to give a guide line for the path of the light brush.

For the second exposure this line was then carefully followed with the light brush, modified for one side with a red gel and for the other with a blue.

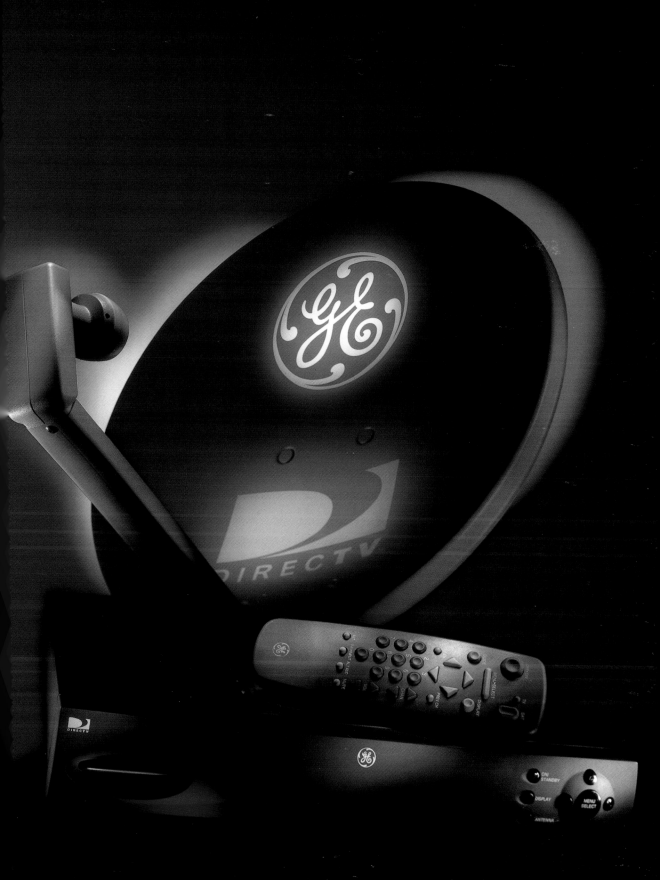

FLYING CDS

photographer **Ron McMillan**

use	studio test
camera	4x5 inch
lens	180mm
film	Fujichrome 100
exposure	f/32
lighting	electronic flash
props and	
background	seamless pre-printed background and fishing line

Ron McMillan explains the thoughts and practicalities behind this effective shot: "This was another attempt to make an otherwise straightforward product shot into something more interesting," he says.

plan view

soft box

background

4x5in
camera

soft box

key points

Some experimentation is necessary to avoid the shiny surface of the CDs flaring into the lens

Apparently tricky special effects can be achieved with simple physical means and a little imagination

"Also, sometimes with portable audible products of this kind, they can all look very alike, despite the fact that they can often have quite different features. So this shot was intended to ensure that the viewer knew immediately that this product included a CD player.

"The product shot was set up in the normal way on a pre-printed seamless background. Then the CDs were taped together on the back of each other with gaffer tape. Then the solid group of discs was hung from an overhead pole out of shot with fishing line taped to the back of the top CD.

"The bottom CD was then secured to the audio unit with adhesive putty hidden from the lens."

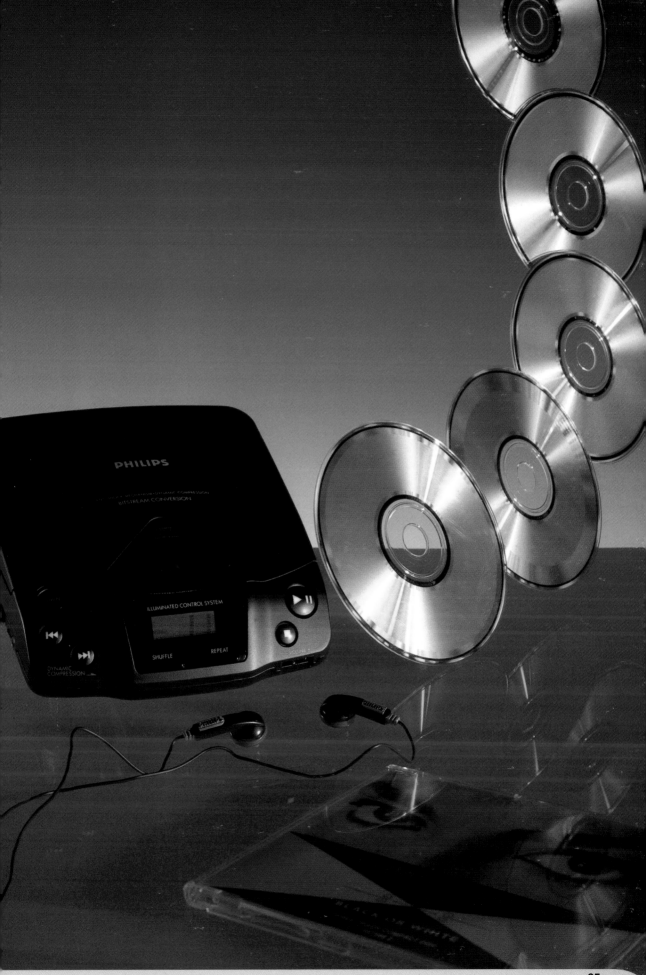

NAVICO

photographer **Ron McMillan**

client	Navico
use	product catalogue
camera	4x5 inch
lens	180mm
film	Fujichrome 100
exposure	f/32
lighting	electronic flash
props and	
background	stones, blue background, water

The challenges faced in trying to capture this moment to fill a brief were difficult but not insurmountable. In order to meet the demands of the client, Ron McMillan simply had to overcome some unique obstacles.

soft box

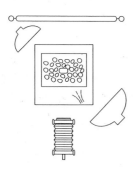

plan view

key points

Keep water way from power packs and make sure you have a means of safely collecting all the excess water in order to prevent it spilling on the studio floor

Experiment with different shutter speeds for different effects of movement or freezing of movement, as required

"The client wanted to show that this product was both waterproof and shockproof," explains Ron McMillan. "One problem was that the normally illuminated dial was too dim to register so the unit was dismantled and a piece of silver paper carved with a clear film with a black read-out on it was put behind the glass window to simulate the normal display.

"At the same time the inside of the speaker grill was taped up to prevent water entering. The unit was then mounted on an upright lead support and dressed with stones below.

"The trick then is to throw water (a small amount, an egg-cup full) aimed at an agreed point on the unit, and fire the flash at precisely the correct moment. Despite being close to the subject, accuracy is difficult and we often missed altogether and the water hit the background. As with all moving liquid shots, you have to keep trying until you feel you have got at least one good one in the can."

photographer's comment

Process all the film and hope, even the successful ones, will each be different.

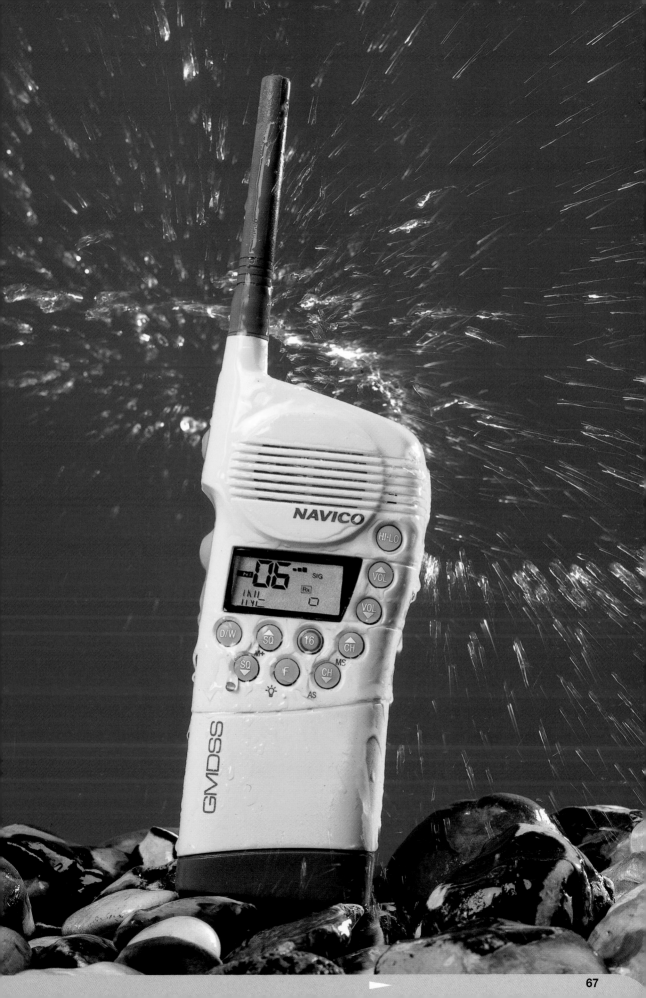

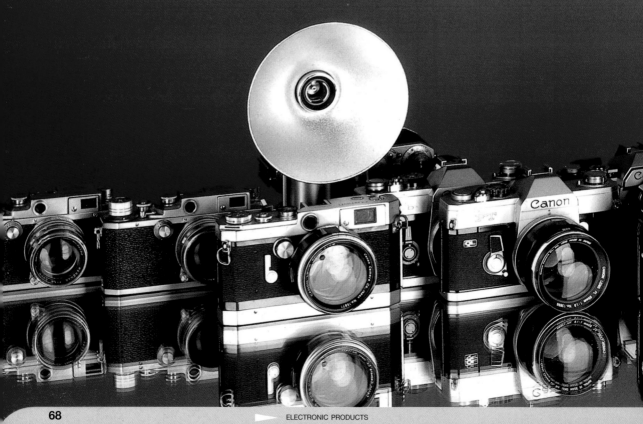

▶ ELECTRONIC PRODUCTS

CAMERAS AND LENSES

photographer **Bob Shell**

client	photo magazine
use	editorial
camera	4x5 inch
lens	90mm
film	Fujichrome 100
exposure	1/60 second at f/16
lighting	electronic flash
props and	
background	red seamless paper

The city landscape-style composition lends interest to the subject matter and avoids the clichéd cluster of equipment arrangement.

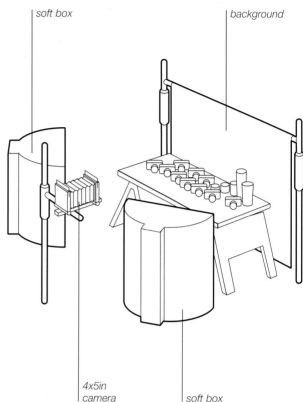

soft box

background

4x5in camera

soft box

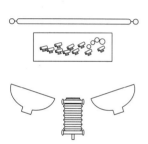

plan view

key points

Before making a final exposure, always thoroughly check all reflective surfaces for possible unwanted reflections

Check too for any smears, fingerprints or speck marks which will show up all too clearly on a reflective or glass surface

There are lots of potential pitfalls in the shot: the mirror surface, the reflective lenses and cameras. Bob Shell has adeptly side-stepped all these problems to create a very professional product shot.

The subject lenses are angled away from the camera just enough to avoid unwanted reflections, while the height of the camera which is recording the

image is only slightly higher than the level of the mirror tabletop. This is so that no lights can be seen in the reflective surface.

Two large soft boxes at 45 degrees are placed one on either side of the photographer giving an even light across the subject. They also are not too high to alleviate any difficulties with seeing them reflected in the glass.

BALDOR

photographer **Gordon Trice**

use	catalogue
camera	4x5 inch
lens	210mm
film	Agfachrome 100
exposure	8 seconds at f/32
lighting	electronic flash

Light is everything in photography and can set the mood of both the image and the viewer.

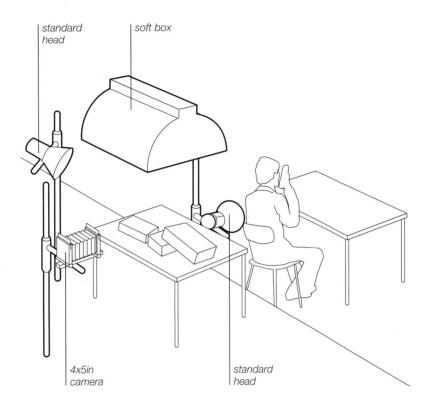

standard head

soft box

4x5in camera

standard head

plan view

key points

Choose an appropriate film for what you are photographing, bearing in mind elements such as latitude and reciprocity characteristics

Simple lighting set-ups generally are the most successful

The overall lighting here was from a Chimera Super-Pro light box on a standard head. This was mounted on a boom and placed directly over the products with just a little spill on the background (to bring up the man using the phone in the chair).

The spill on to the background serves two purposes: first, to soften he shadows of the hot light; and second, to add a little daylight into the tungsten background. Placement of the soft box is also crucial in the highlights on the penknife and on the electrodes of the tester. A third light is placed on a stand just above the tabletop and off to the left of the camera with an extremely narrow grid over the reflector.

This light is to give the black flash light case a little 'kick'. It also highlights the flashlight just a little.

photographer's comment
The motion of the person in the background was choreographed several times prior to the exposure of the film.

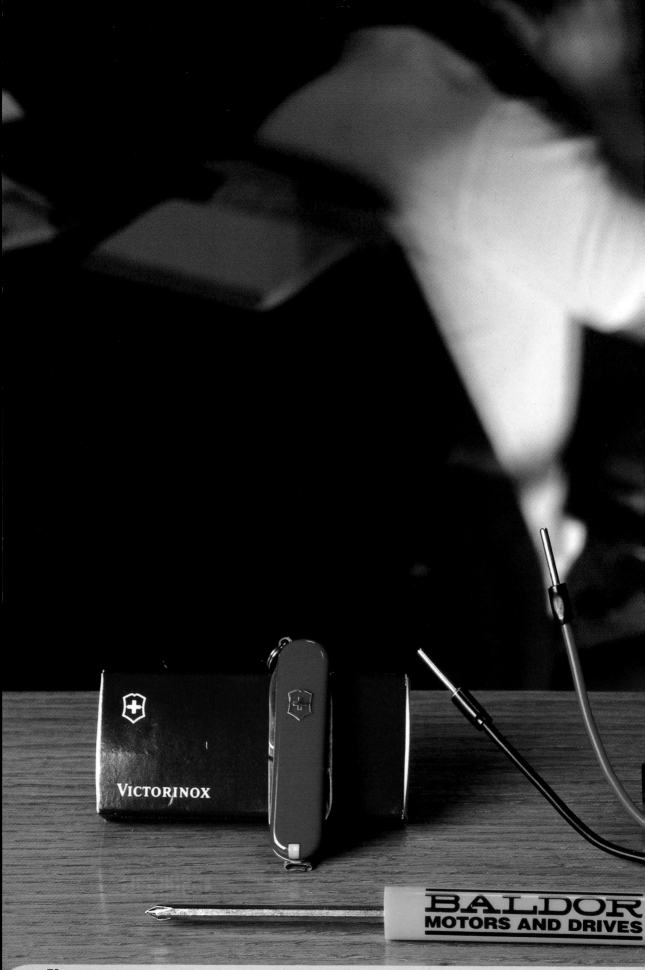

DIVING WATCH

photographer **Agelou Ioannis**

client	The Diving Centre
use	editorial
assistant	Anestij Rekkas
camera	digital format
lens	Standard
film	SCSI connection to PC
exposure	not recorded
lighting	electronic flash
props and	
background	plain blue paper

This shot was achieved by digital means, both at the point of origination and in the after-treatment via Photoshop.

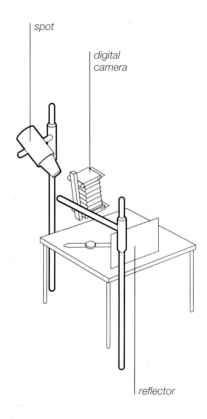

plan view

key points

Lighting for digital origination need not be any different from lighting for shooting onto film, although a digital original can be electronically re-lit to some extent within the capabilities of the post-production electronic treatment

It is best to shoot any image "clean". The beauty of the digital medium is that effects can always be applied afterwards and then undone if the results are not satisfactory

"Time was minimal as (almost) always," explains photographer Agelou Ioannis. "We did the shot on Saturday night, played around with Photoshop next morning, and delivered hard copy for proofing later that day. The client liked this one best and he had the file on a disk first thing on Monday morning. The effect would be extremely time-consuming or next to impossible without digital means.

"The lighting was very simple. A simple spot head from above to the left of the camera and a white fill card to the right. It was important that we didn't have any reflections on the watch front glass."

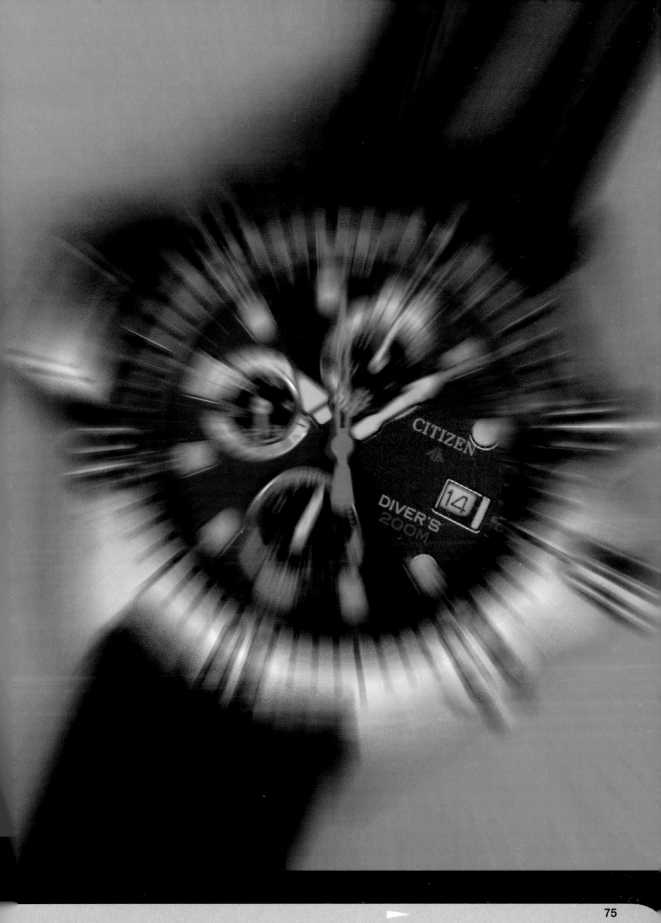

LENS

photographer **Bob Shell**

Sometimes when an object is photographed the whole image will not be the end result. This shot demonstrates an example of this concept.

use	editorial
camera	4x5 inch
lens	150mm
film	Kodak E100S
exposure	1/60 second at f/22
lighting	electronic flash
props and	
background	white seamless paper

reflector background

4x5 in
camera soft box

plan view

key points

When compositing images, plan out the final composition so that there can be continuity to the lighting

Dark objects absorb a lot of light, so control the lighting ratio to make writing or markings clearly visible

The lens we see here against a white background is actually going to be cut out to form part of a montage of other camera equipment. Therefore the background, visually, is not important and can be utilised more as a supplement to the lighting, rather than having to be lit itself. This lens poses the problem of being a semi-reflective black surface and will need a lot of illumination to model it. It is also of great importance to make the markings all legible as possible. The photographer here uses a soft box and a reflector at close proximity to produce the required lighting level.

The background is used to return light which again will also reflect off the white reflector and the front of the soft box itself.

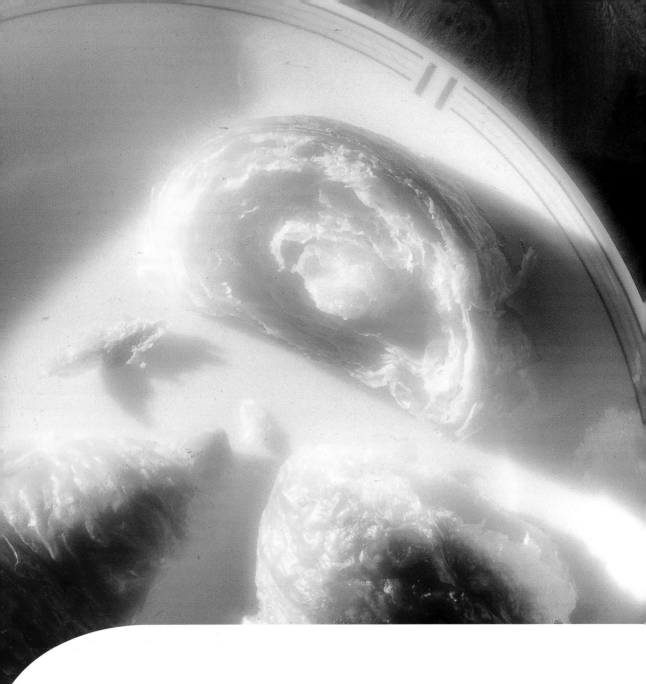

FOOD and DRINK

04

A product shot is not always going to involve a branded product. More and more, advertising campaigns focus on generic products rather than specific ones. A huge amount of advertising is now commissioned by supermarkets emphasising the overall range of the stock, its quality, value for money, exclusive flavour, or suitability for specific types of cooking, and so on. For this reason, many product shots that are commissioned in the world of food retailing and production involve unbranded samples of types of food, and there is a considerable cross-over between table-top still life, creative fine art photography styles and even abstract or surrealist work using food zero subjects. Whether branded or unbranded products, the photographers in this chapter demonstrate the creative flair that must be brought to bear on even the humbles t of products that are (sometimes literally) the bread-and-butter of everyday life.

CHILLIES and MILK

photographer **Nick Welsh**

use	personal
camera	8x10 inch
lens	240mm
film	Kodak EPP
exposure	f/8
lighting	electronic flash

This is a wonderful photograph representing a unique approach to an otherwise basic idea: fire.

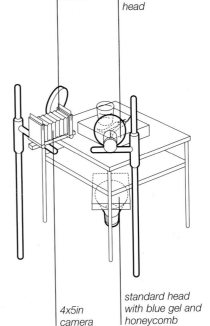

mirror

standard head

4x5in camera

standard head with blue gel and honeycomb

plan view

key points

How an idea is presented is as important as what is being presented and is at the heart of creative expression

Stark contrasts such as this often present the most interesting challenges to the photographer

The chillies and glass of milk are standing on a block of acrylic ice which in turn is placed on a glass table top. The size and position of the ice block are evident from the blue square area on the table top. Below the table top is an upward-pointing standard head with honeycomb and blue gel. The light is diffused by a sheet between the light and table top to give the bright, even background. The blue gel supplies the coloured detail in the area of the table top that is directly above the acrylic ice block, and, in turn, through the glass tumbler itself. The red reflection detail on the tumbler surface nearest the chillies gives a pleasing touch of colour contrast, bringing the hot and cold (in terms of taste temperature - hot chillies and cold milk - as well as perceived colour temperatures - hot red and cold blue) into playful juxtaposition.

To the right of camera and at 45 degrees is a standard head providing directional lighting on the chillies providing highlights on the upper surfaces plus deep shadows at the edges for contrast and definition. It also ensures the brilliant white look on the upper surface of the milk. The mirror to the left is a further source of highlights.

photographer's comment

I was asked to produce a personal shot representing fire. This is the result.

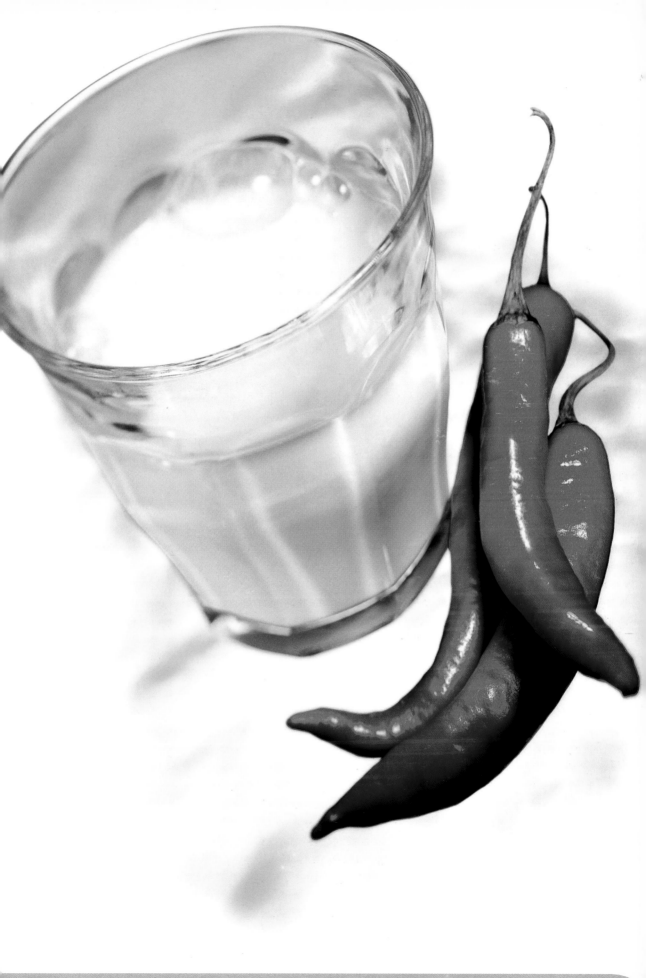

PRAWN SOUP

photographer **Catherine McMillan**

use	self-promotion
assistant	Chris Dickinson
stylist	Tony Brown
camera	8x10 inch
lens	400mm
film	Ektachrome 100
exposure	f/32
lighting	light box, light brush
props and	
background	fabric, plate, bowl, grass

This swirling shot has tremendous impact and the flavour and aroma of the subject soup are almost tangible.

light brush 8x10in camera light box

plan view

key points

Unity in composition need not come only from subject. A more abstract quality such as iridescence can be used as a central theme for a shot, or as an element to tie together disparate elements to stunning effect

It may be more convenient to shoot with the subject in one orientation with the full intention of eventually rotating the image for final presentation

Catherine MacMillan has achieved this by combining an expert choice of props, immaculate styling, thoughtful composition and a very precise lighting set-up that makes the most of and works with the forms of the subject items.

The light box is set upright and very close in alongside the subject to give side light across the subject and the 8x10 inch Sinar camera is suspended directly overhead. The light brush is then used precisely to pick out and enhance the grass stems that are arranged to perfection to echo the shape and position of the shrimp. The natural three-dimensional curvature of the various elements of the composition is enough to ensure a good degree of modelling and textural interest.

photographer's comment

The light box is placed as close as possible and the Hosemaster used to enhance the grass.

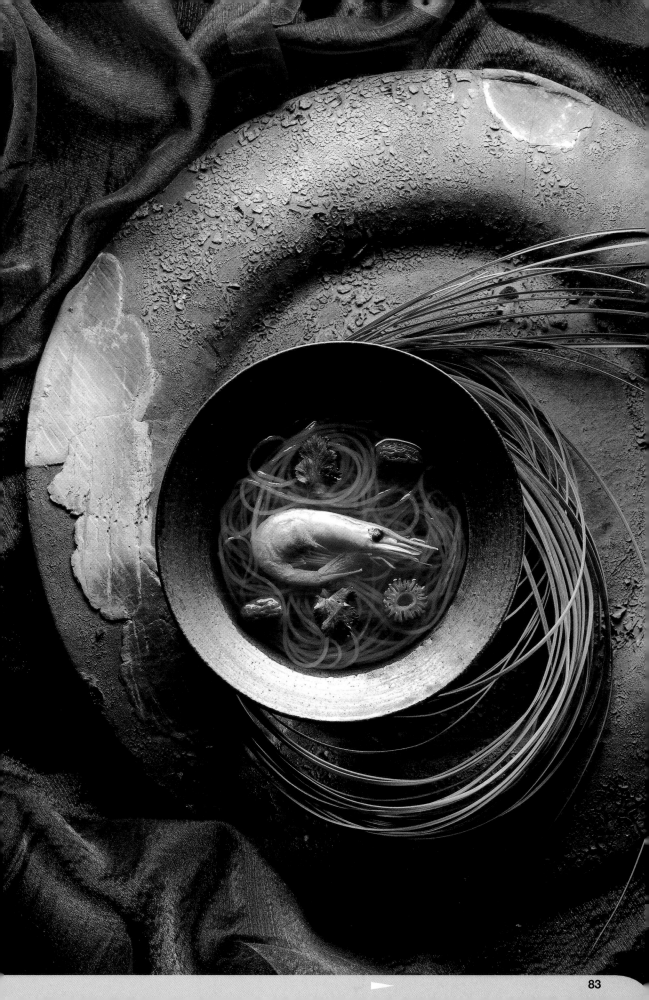

A gente só nã...

mil e ...

para não...

Knorr®
CALDO DE LEGUMES

Knorr®
CALDO DE GALINHA

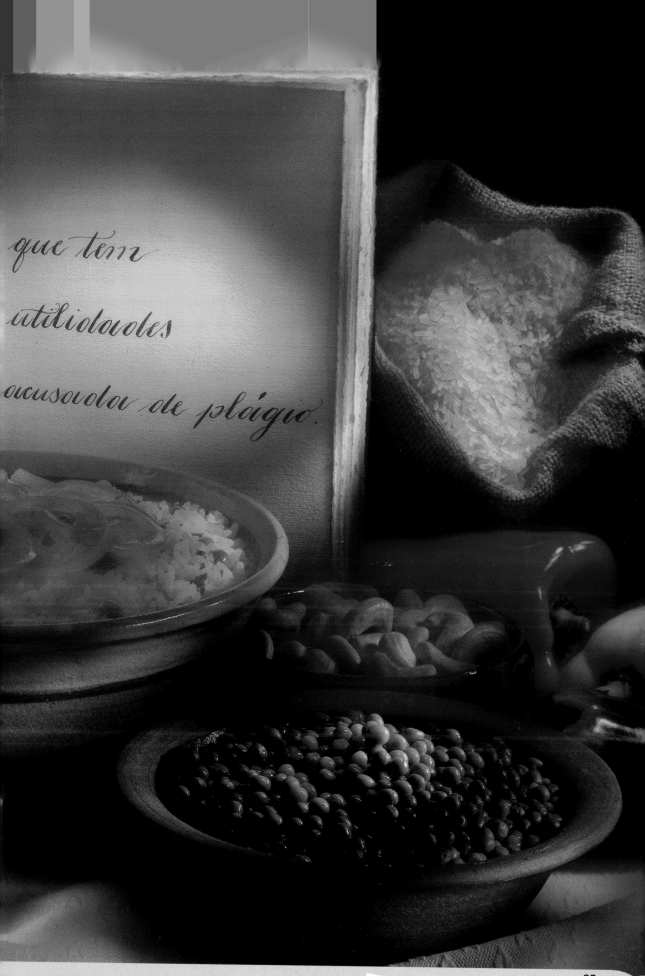

que tem

utilidades

acusada de plágio.

BOOK OF RECIPES

photographer **Ricardo de Vicq de Cumptich**

client	Knorr
use	advertising
assistant	Ednaldo de Sousa Ramos
art director	Roderigo Butori
agency	Young and Rubicam
camera	4x5 inch
lens	210mm
film	EPP
exposure	not recorded
lighting	electronic flash plus light brush

The painted sky background is illuminated by two standard heads modified by honeycombs. However, the background is kept relatively low key.

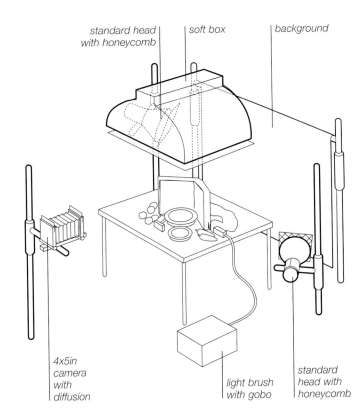

standard head with honeycomb · soft box · background

4x5in camera with diffusion

light brush with gobo

standard head with honeycomb

plan view

key points

Light intensity and balance can be altered by changing power, by changing distance, by adding filtration or by making multiple exposures at different apertures

Light brushes are normally used in conjunction with other light sources

The whole table top is lit from above by a one metre square soft box and there is a diffuser over the lens for this initial exposure. The highlight areas such as the writing in the book, the corners of the book, the hero packets and various other items of food are then lit separately with the light brush, giving the characteristic pearly inner glow to these areas. It is interesting to note the difference of "touch" between the areas of initial exposure with diffuser, which are quite soft, and the light brushed areas without diffuser, which come out noticeably sharp by comparison.

DRINK-FIT DRINKS RANGE

photographer **Mark Asher**

client	Immergut-Milch GMBH
use	poster and mail shots
other	Richard and Ron Hasler of Immergut-Milch
camera	4x5 inch
lens	Schneider 210mm
film	Fuji Provia 120
exposure	1 second at f/22
lighting	electronic flash and tungsten
props and	
background	handmade paper scoop, a small glass containing strawberry drink and products supported on paper covered blocks.

"The flash head was at three-quarter power (reading at f/22 on the light meter) and the tungsten spot light was allowed to run on for 1 second. It was also fully corrected to balance it to the daylight film," explains Mark Asher.

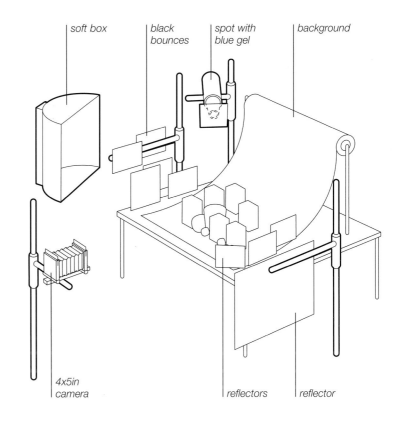

soft box black bounces spot with blue gel background

4x5in camera

reflectors reflector

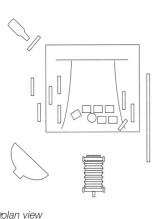

plan view

key points

White reflector cards provide diffuse fill light whereas mirrors provide more directional fill-in

Full blue correction is required to make tungsten light which is 3200° Kelvin match electronic flash, at 5600° Kelvin

A good depth of field is required to hold all the products sharply in focus from front to back and the soft box provides good even illumination keying all of the products from camera left.

The tungsten focusing spot aimed at the back of the products provides a little separation from the background. Side-on to the products on the right of the camera Mark Asher uses a range of mirrors and white card reflectors to add fill-in to the right hand side of the packs. All the packs are actually the same size but to make for a more interesting composition the cartons at the back are placed on blocks which are hidden by the fruit, glass and front row of products.

photographer's comment

The lighting on the background helps give interest without distracting from the product itself. The arrangement of the cartons on different levels enables them all to be seen clearly, but without being too regimented.

CHINESE MEAL

photographer **Jonathan Pollock**

client	Oriental Food Company
use	poster
assistant	Liz Leahy
other	Jenny Berrisford
camera	4x5 inch
lens	210mm
film	Kodak 100 Plus
exposure	1/30 second at f/32
lighting	electronic flash
props and	
background	black velvet

The subject of this exquisite shot is immaculately and carefully styled, as demanded by the subject itself.

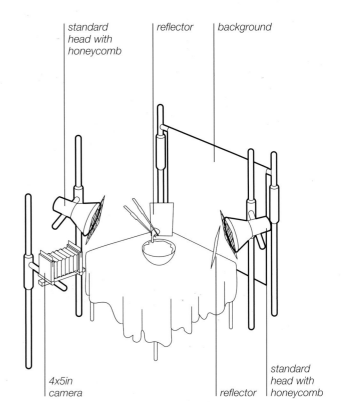

standard head with honeycomb reflector background

4x5in camera reflector standard head with honeycomb

plan view

key points

When lighting food, it is essential to work quickly to maintain the fresh appearance

Have large quantities of the product available to replenish food subjects as required

The perfect morsels of food are arranged beautifully in the black bowl and the gleaming chopsticks are held in place by a rig. More food is draped over the chopsticks and the shoot is ready to begin.

Jonathan Pollock has chosen to use two square soft boxes placed diagonally opposite each other. These are both modified with honeycombs, which have the effect of concentrating the light on to the food rather than on to the bowl. Just the very rim of the bowl is picked up separately by light bounced back from two small white reflector cards. The black velvet background and black bowl together give a cradle of darkness against which the brilliantly coloured food can sing out.

photographer's comment

The effect of the black and the lighting contrasting against the beautiful colours draws the food out of the paper towards the onlooker.

SPICES

photographer **Peter Millard**

use	portfolio
camera	4x5 inch
lens	240mm
film	Fuji 64T
exposure	not recorded
lighting	tungsten

The beauty of this shot is the effective but simple lighting combined with a sensitive and considered arrangement of items chosen for their form, colours and textures.

plan view

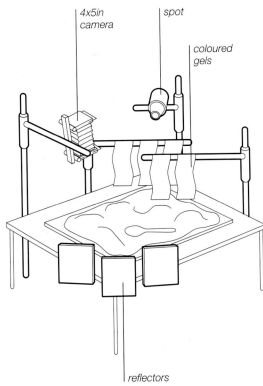

key points

Silver reflectors give a more directional bounce light than plain white reflectors

Gold reflectors will return less light as they absorb more of the spectrum than white and silver reflectors do

The shot was taken from directly overhead and tightly cropped so that very little background shows through between the spices – although it was actually shot on a plain mahogany chopping board.

A one kilowatt tungsten spotlight was used to give the shadows, and strips of orange lighting gel were used to selectively warm up certain areas of the spices, whilst leaving other areas of the shot neutral. A soft focus filter (Cokin No. 1) was used to make the highlights from the nutmeg, spoon and cinnamon glow. There are some small white and silver reflectors to control fill-in directly opposite the one kilowatt tungsten light, which is along way back to get long shadows and moody light.

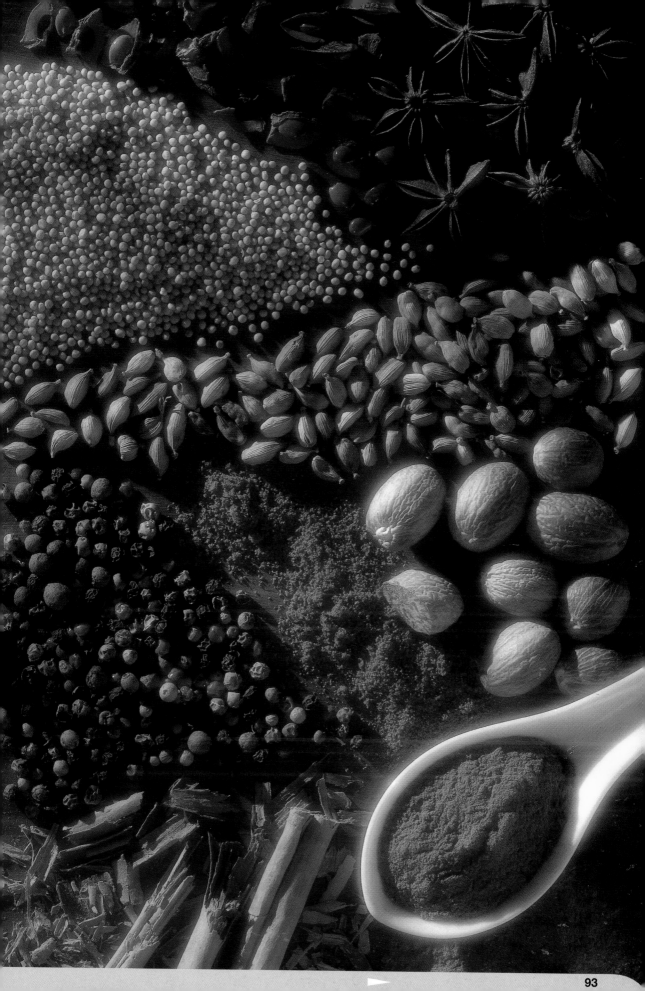

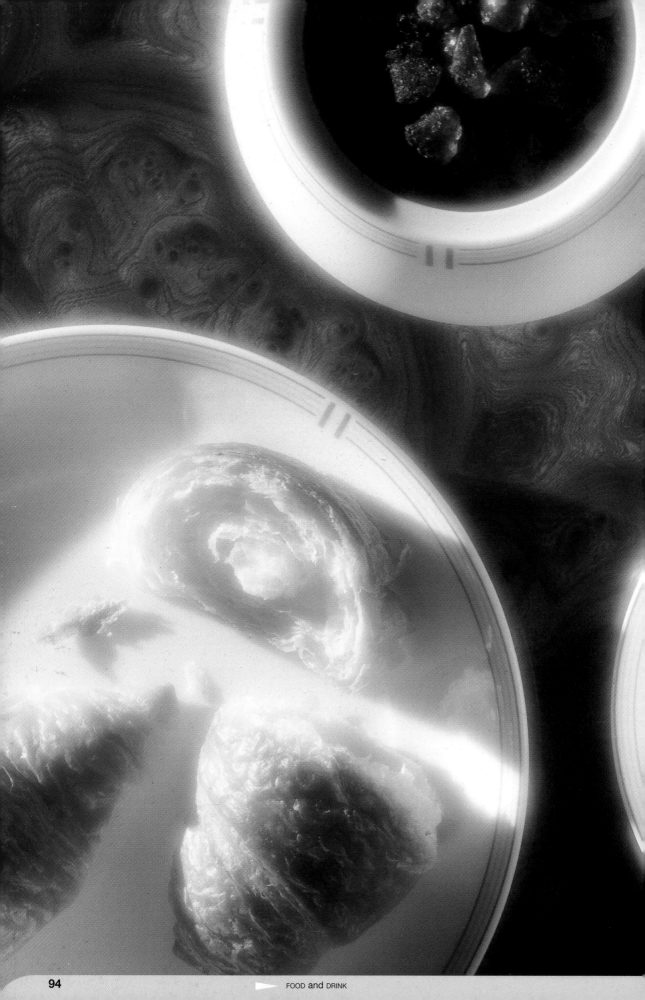

FOOD and DRINK

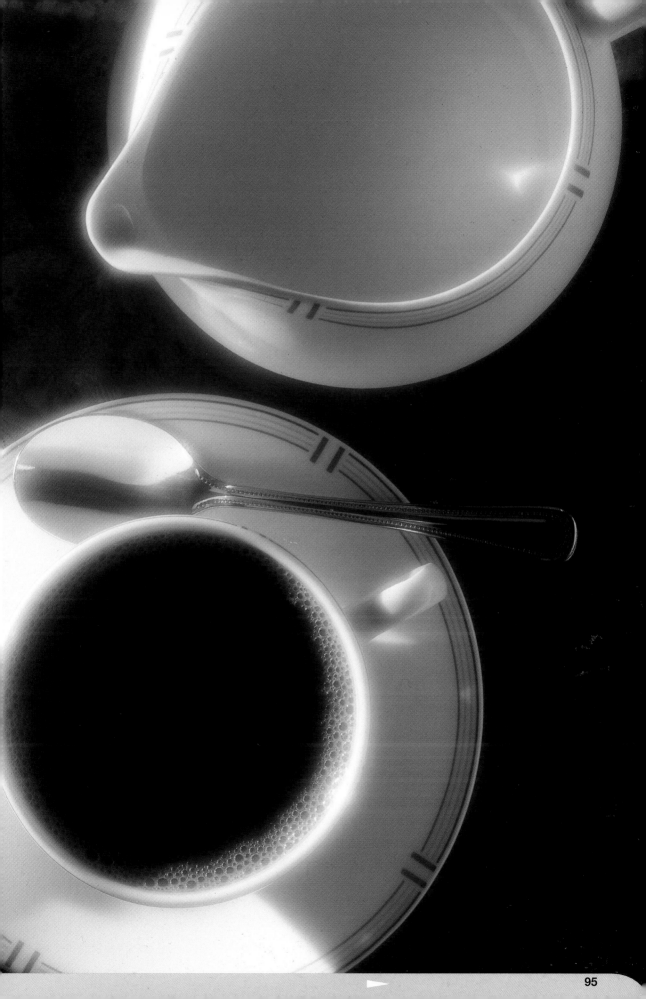

CROISSANT

photographer **Peter Millard**

use	personal work
camera	half plate
lens	300mm
film	Kodak 6118
exposure	not recorded
lighting	tungsten
props and	
background	maple table top

When Peter Millard found he had a very expensive and beautiful table-top just hanging around his studio waiting to be returned to the hire company, he took advantage of the opportunity to use it as a prop.

half plate camera

spot

silver reflector

reflector

plan view

key points

A single light source is often a good starting point for experimentation and may be all that is required

The larger the format of the camera, the more shadow detail can be seen

With the aid of just one tungsten spotlight, a large white reflector card for fill-in and a small low silver fill-in to catch the end of the spoon, created this stunning morning coffee shot.

"The shot was taken from directly overhead and with strong lighting from a one kilowatt tungsten spot. I wanted to give a bright and breezy early morning café feel to the picture," he comments. "The background was a beautiful and expensive Birds-eye Maple table that had been hired from a background company for another job (another coffee client) and was "resting" in my studio pending return. After I'd shot a black and white Polaroid, I knew that I also had to cover it in black and white because it looked so good. A soft focus filter was used to make the edges of the china glow. The final crop was carefully selected "in camera" as there is less space to play with on half-plate than there is on 8x10 inch."

PASTA

photographer **Chris Rout**

It takes an artist's eye and imagination to identify and exploit the exciting visual potential in the commonplace everyday objects that we come into contact with all the time.

se	stock
amera	RZ67
ns	110mm
lm	Fuji Velvia
xposure	not recorded
ghting	electronic flash
rops and	
ackground	pasta

spot with honeycomb 6x7cm camera

an view

ey points

ome food products will be affected
y the heat of studio lights so it is
mportant to have replacements
tanding by

ontrolled fall-off can help to make
he most of intricate details of
teresting forms

Chris Rout has taken a handful of humble dry spaghetti and created a striking graphic composition.

The styling is all-important, providing both form and texture for the lighting to pick up. The shot is lit by a single standard head with a honeycomb grid, positioned at quite a low angle to give a good amount of modelling to each individual strand of spaghetti, and throwing a long shadow from the uppermost pasta twists.

The fall-off gradation down the length of the picture adds to the interest and puts one in mind of a formal study in tonality, composition and form, and is an excellent example of a simple idea simply executed, to good effect.

FOOD and DRINK

LIFESTYLE and

05 LEISURE PRODUCTS

Lifestyle and leisure activities are a large part of our daily experience, and the products we use for these aspects of our lives are many and varied. From the simple condiment bottle on the kitchen table to the top-of-the-range bike gear, any amount of the items that we surround ourselves with, just to live life, may become the hero of a product campaign. Promoting the familiar effectively takes a great deal of imagination and a great deal of care in terms of product placement, styling and so on. Promoting the more exotic and specialist leisure equipment is in some ways at the other extreme of the market, yet often the imaginative appeal must be similar: the image must tempt the viewer to associate themselves and some part of their life with the product, albeit as a one-off treat, perhaps, rather than as an everyday necessity or convenience.

SHOES

photographer **Romylos Parissis**

client	Weekender
use	advertising
art director	D. Patridios
camera	4x5 inch
lens	210mm
film	Kodak EPR
exposure	f/45
lighting	electronic flash
background	frosted Plexiglass

The main light comes from a soft box behind the shoes which is enough to give good modelling.

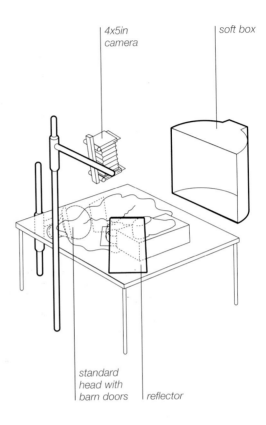

4x5in camera

soft box

standard head with barn doors

reflector

plan view

key points

It is important that the product featured should be immaculately presented, without finger marks, scuffs or any other blemishes

Background materials can be multi-purpose and act as diffusers, gels or reflectors

To avoid the problem of lighting from directly above and the risk of inducing speculas, the paper and the table are lit from beneath. The bottom of the shoe box was removed in order to allow more light through.

The camera was positioned almost directly overhead to achieve a flat-on view of one shoe from above and the other in strong profile. The graphic composition of the shoes and box is softened by the texture of the crumpled tissue packing paper.

The shoe box, importantly, bears the logo branding for the product and is positioned boldly to emphasise the graphic (as well as commercial) element of the composition.

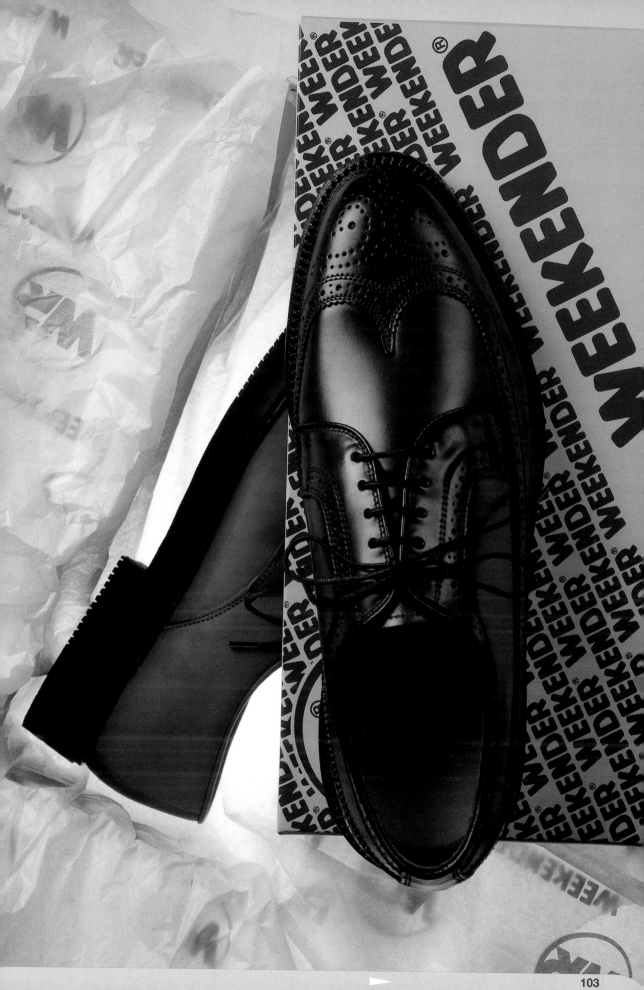

WINE GLASSES

photographer **Jonathan Pollock**

client	London department store
use	advertising
assistant	Liz Leahy
stylist	Sue Russell
camera	4x5 inch
lens	360mm
film	Kodak 100 Plus
exposure	1/30 second at f/8
lighting	electronic flash, tungsten
props and	
background	large sheet of
	sand-blasted glass

The crystal icy blue of the image comes from a standard head to the back left. It is modified by a blue gel and bounces off a large white reflector board to the back left, as can be seen clearly on the upper surface of the silver rimmed piece of crystal at the back.

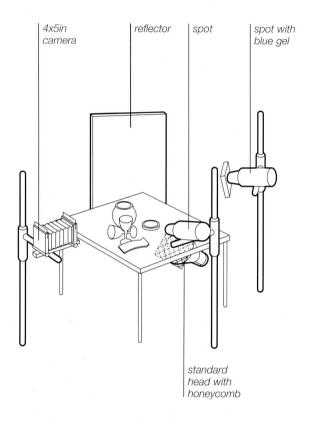

4x5in camera · reflector · spot · spot with blue gel

standard head with honeycomb

plan view

key points

Mixing uncorrected tungsten and flash light sources can give interesting coloured highlights and low lights, but remember to adjust the power settings to achieve the required exposure

In contrast to this, on the right is a tungsten head, more frontally placed than the blue gelled head. This light shoots directly into the scene, giving a warm edge and glow to the objects from the right hand side; notice, for instance the golden highlights on the coiled detail on the stem of the upright glass, and on the right edges of the calculator number buttons.

The main illumination comes from a soft box below the glass table. The sand blasted finish of the glass table top diffuses this light somewhat.

photographer's comment

This succeeds by using a limited depth of field and bounced blue lighting. This contrasts with the soft highlights creating a subtle atmosphere.

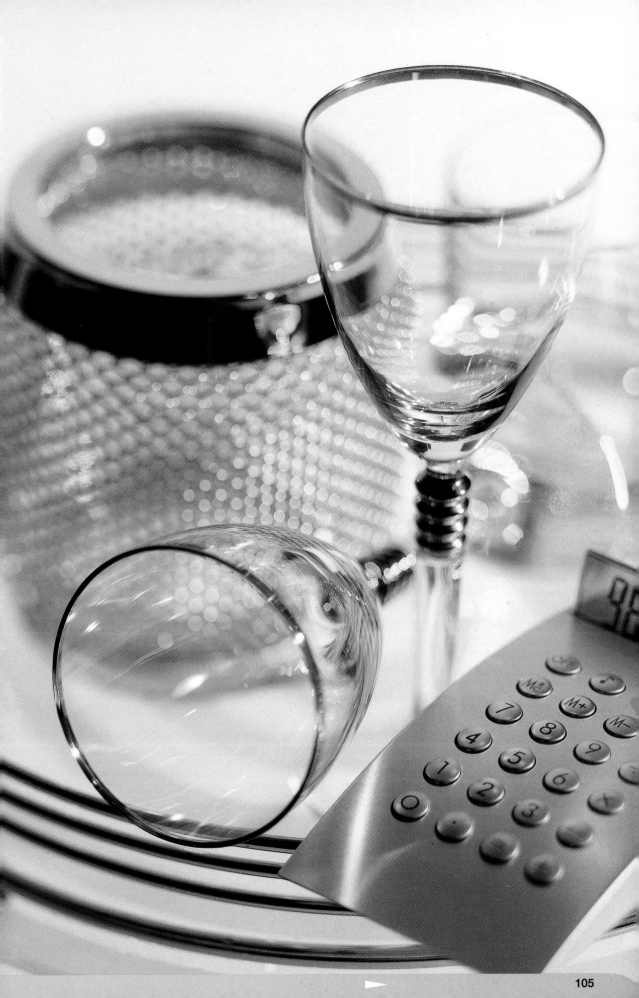

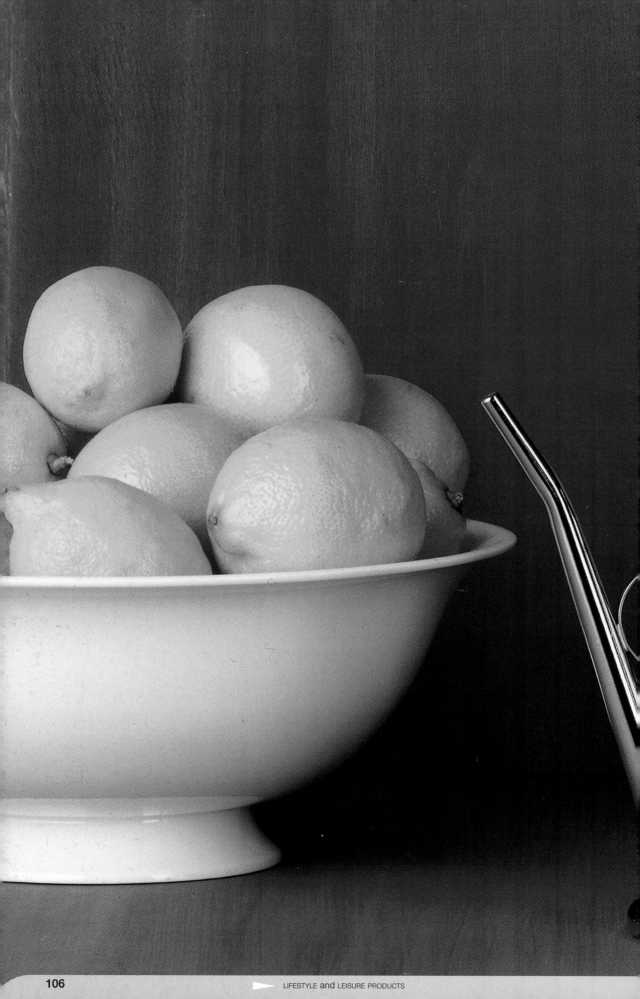

▶ LIFESTYLE and LEISURE PRODUCTS

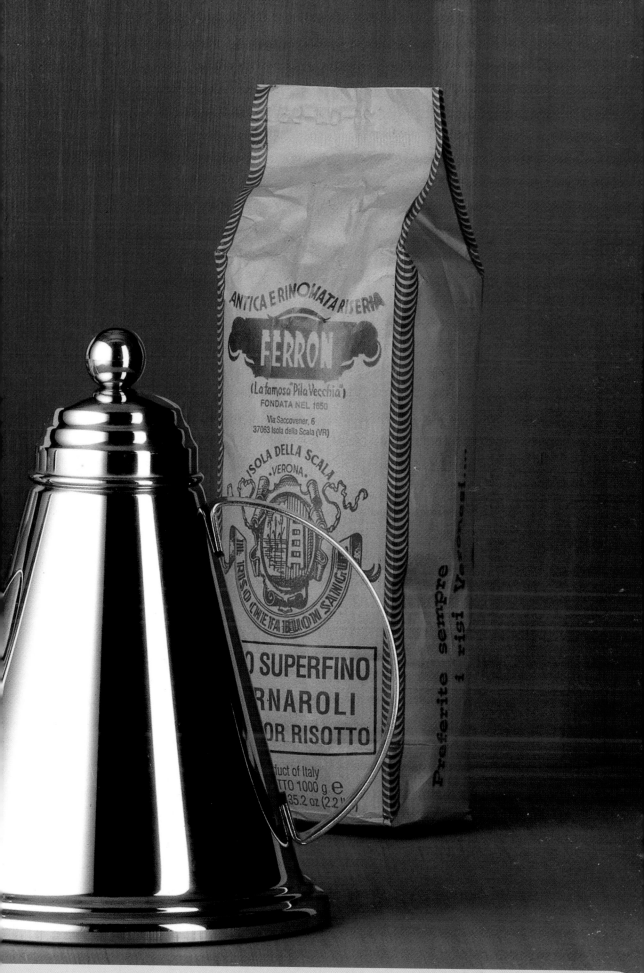

OLIVE OIL CAN

photographer **Jonathan Pollock**

client	kitchen mail order company
use	cover shot
assistant	Liz Leahy
camera	4x5 inch
lens	360mm
film	Kodak 100 Plus
exposure	1/30 second at f/45
lighting	electronic flash
props and background	two pieces of MDF board, painted, bowl of lemons

This apparently sunny and evocative life-style shot is in fact a studio-based image with sunlight simulated by a large soft box to the left of the camera.

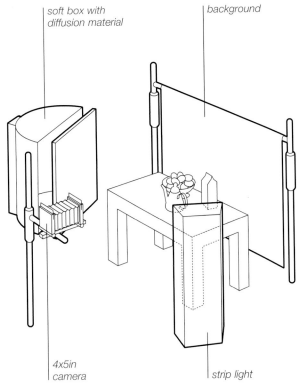

soft box with diffusion material

background

4x5in camera

strip light

plan view

key points

It is important when working with a very reflective prop that no unwanted reflections are seen

Careful control of the range of colours used can add an element of unity to a composition

The soft box shoots through a large sheet of perspex one foot in front of the soft box. This has the effect of diffusing the light throughout the scene and reduces the risk of having a distinct reflection of a soft box in the oil can. Instead, a long even gleam is apparent, but it is not apparent that this is not caused by the sun. A strip light on the right of the camera gives a second strip of light in the oil can, emphasising the curvature of its shape. Since this source is on a steeper angle, no perspex is needed in this case.

photographer's comment

The success of the picture lies simply in the tightness of composition and the restricted use of colour creating a strong graphic image for the front cover.

HIKING SHOES

photographer **Renata Ratajczyk**

There are no hard and fast rules for working with a light brush: experimentation is the single most important technique.

se	personal work
amera	6x6cm
ens	90mm
lm	Fuji Provia 100
xposure	not recorded
ghting	light brush
rops and	
ackground	hand painted canvas background, shelf

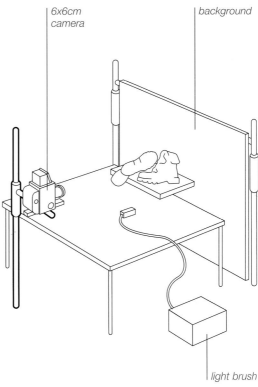

lan view

key points

* is important that the light brush s constantly moving during the xposure

Skill and experience plus extensive experimentation and testing is equired. Good note-keeping will be invaluable!

It is worth working out beforehand which areas are to be treated with the light brush, where the highlights are required and which areas are to be left dark; but equally, it can be interesting to improvise during the exposure itself (though more difficult to reproduce if the work done is not recorded!).

Control of the light brush is another aspect of this technique which again has to be acquired with practice.

The intention and the actual execution may take some time to match up. Renata Ratajczyk's expert control of the technique is shown to excellent effect in this moody shot which is lit entirely with the light brush. There is a general even application of light across the whole area of the subject initially, and then specific areas of highlight have been smoothly worked on individually.

photographer's comment

The distance of the light brush from the subject and the time necessary for proper exposure have to be determined by experimentation.

LIFESTYLE and LEISURE PRODUCTS

BICYCLE

photographer **Gordon Trice**

client	Zachry Associates
use	brochure
camera	4x5 inch
lens	210mm
film	Fuji Velvia
exposure	not recorded
lighting	electronic flash
props and	
background	bicycle

A stand was made to hold the bicycle and rider, sturdy enough to allow some movement of the rider and tires of the bicycle.

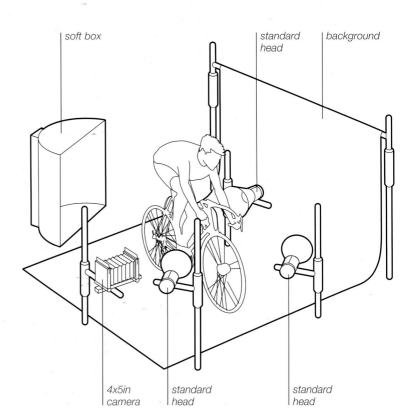

plan view

key points

Dulling spray is available to reduce the level of reflectivity from chrome or other shiny surfaces

Thoroughly check rigs before asking a model to mount the arrangement

Four heads were used to light the shot, three of which had different coloured gels. The fourth had a Chimera super-pro medium soft box.

The spots with the red and green gels are used to light the background while a yellow gelled spot to camera left is aimed at the bicycle. The main over-all light, however, is the medium-sized soft box to camera left, angled so that it is straight on in relation to the subject, though this is at 45 degrees to the camera.

The resultant highlights on the chrome of the bicycle stand out superbly against the deeper coloured background, and the shoe and leg are absorbed into the composition as more working parts to the subject in this very effective composition.

photographer's comment

The rider's legs were shaved and make-up applied.

BURBERRY

photographer **Alan Randall**

use	advertising
client	Burberry
camera	4x5inch
lens	150mm
film	Fuji Velvia
exposure	1/60 second at f/32
lighting	electronic flash
props and	
background	seat, shoes and umbrella

Sometimes it is enough only to see part of the name of a branded product in a shot, especially if the corporate image has been built upon for many years.

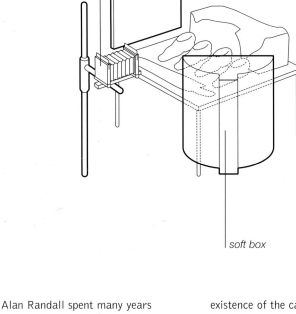

4x5 in camera

black bounce

soft box

plan view

key points

Building up a corporate image will allow more creativity later on

The colours and reflectivity of products will ultimately determine the lighting style to be used

Alan Randall spent many years visiting English stately homes and photographing Burberry products. Establishing the quality of the goods and the clientele can have a psychological effect on the public, and make them think they can have a better standard of living if they buy the right clothes and shoes. The photographer's job is to portray the goods in a way that makes the existence of the camera transparent, but at the same time by the use of appropriate lighting, makes the product irresistible. This shot is quite simply lit by a soft box to the right of the camera providing good strong highlights in the shoes to show off their attractive shape. A black panel to the left of the camera increases the fall-off of light, thus emphasising the shape more.

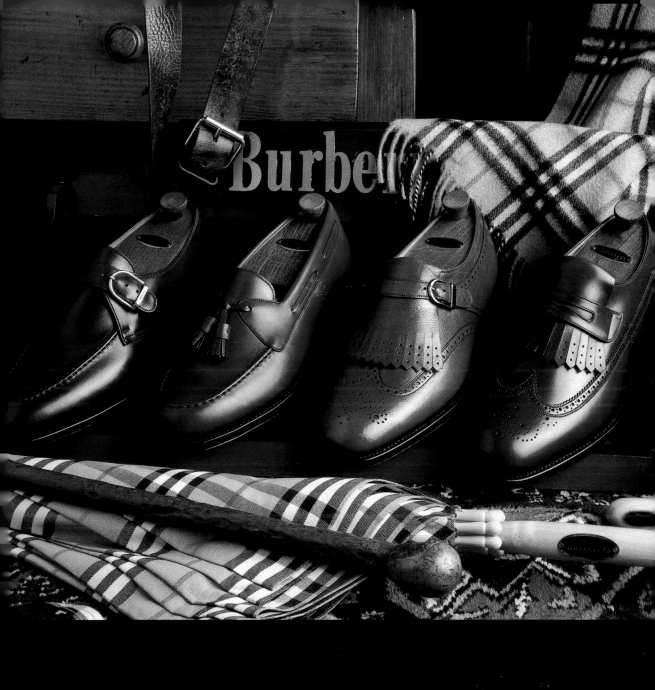

HARRODS

photographer **Alan Randall**

use	advertorial
client	Vogue editorial
camera	4x5 inch
lens	150mm
film	Fuji Velvia
exposure	1/60 second at f/32
lighting	tungsten
props and	
background	leather writing pad, embroidered fabric

When the products being photographed consist of silver and crystal, a sparkling and luxurious look is likely to be the desired result. Indeed, "silvery" and "crystal-clear" are terms used to the represent those unique sparkling qualities in a range of other contexts.

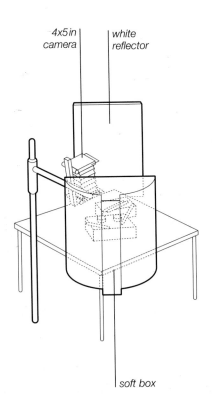

4x5in camera white reflector

soft box

plan view

key points

Shiny objects must be immaculately clean; every mark or smear will show

Large soft boxes are very good to illustrate the shape of an object but the effect will be spoiled if the reflection shows the soft box source itself

In this case, Alan Randall has achieved the required gleam on these intrinsically sparkling items by using a soft box arranged so that the source shines directly forwards through the front silk, giving a more focused, direct, "harder" soft light than the usual reflector within the box arrangement.

Overall the look is quite low key and this serves to emphasise the shine and the contours of the cut glass.

photographer's comment
The point of the shot was to make the glass and silver glow.

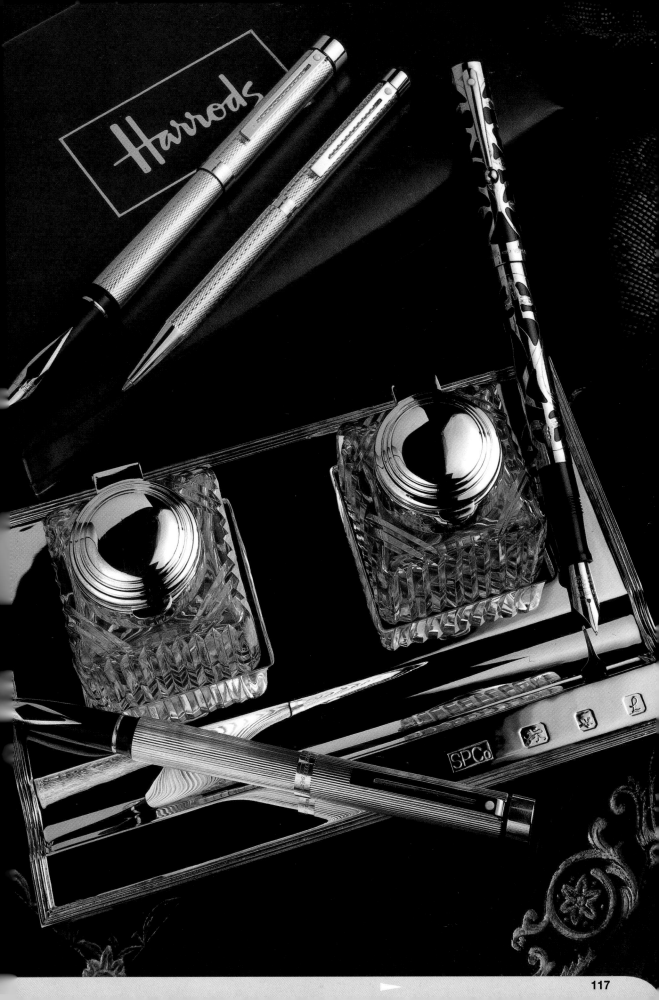

FASHION
ACCESSORIES
06

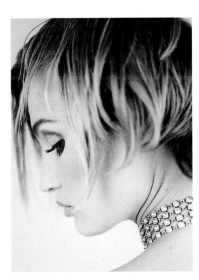

Fashion accessories can include anything from the obvious personal adornments to the trappings of particular lifestyle or group: even a soft drink has fashion value these days. It does not just have to taste good, it has to have the right associations for the target market and a street credibility that has little to do with flavour or nutritional content. The same can be said for a wide range of products. The meaning of the word "fashion" in this chapter, therefore, embraces more than just clothing. Drinks, sports shoes, sunglasses, watches and jewellery all help to define a lifestyle and social affiliation for fashion-conscious consumers, and the methods of appealing to them through commercial imagery are represented in various forms in this chapter. The fashions of the shots representing fashions are as prone to vogue as are the fashions themselves and it is difficult to imagine a long shelf-life for any kind of imagery bound up in the ever-changing world of fashion.

DIOR GLASSES

photographer **Jeff Manzetti**

client	Dior
use	advertisement
model	Diane Heidkrugger
hair and	
make-up	Yannick Dys,
	Pascale Guichard
stylist	Laurence Heller
camera	Pentax 67
lens	135mm
film	Kodak GPX
exposure	f/8
lighting	electronic flash

The raison d'être of this book is to describe the lighting set-ups in detail and explain the complexities and intricacies of the arrangement. In a case such as this, however, the task is so straightforward as to be unexpectedly difficult; for this stunning image is simply lit with nothing more complicated than a single large soft box.

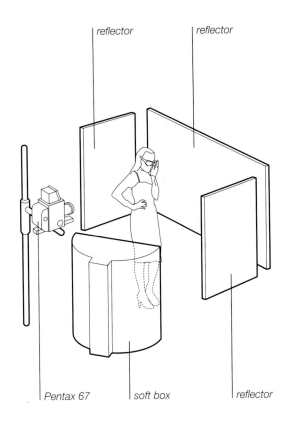

reflector reflector

Pentax 67 soft box reflector

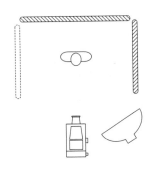

plan view

key points

Start lighting with a single source – add extra lights only if it is necessary

The larger the format, the better the detail recorded in the shadow areas

Of course there are many other elements that contribute to the success of the shot. Styling, hair, make-up, choice of model, props, clothing, background, branding... all combine perfectly for a technically simple yet extremely sophisticated and stylish result. The art of the photographer is to know exactly where to place the light in relation to the model, and to be aware of the interplay of light on reflective and non reflective surfaces. Close examination of any small area of detail is well worth the effort here.

Note the detailing of the lettering on the sunglasses picked out by the light, or the play of light on the hand.

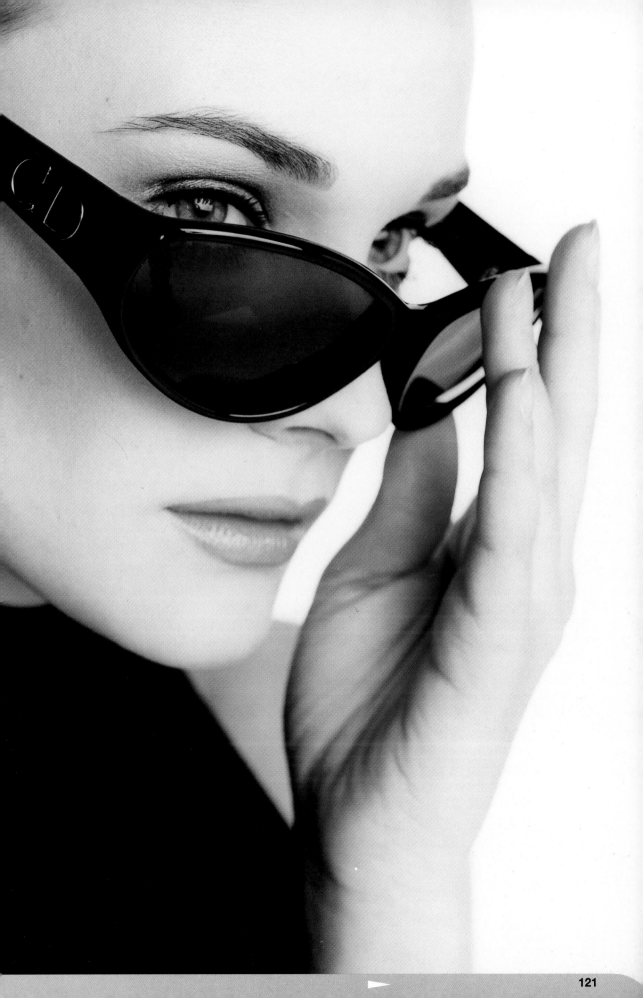

THREE EYE GLASSES

photographer **Agelou Ioannis**

client	cosmetics store
use	promo posters
assistant	Mario Archontis
art director	Maria Alexandris
camera	6x7cm
lens	90mm
film	Fuji Velvia
exposure	1/60 second at f/11
lighting	electronic flash
props and background	wooden base, thick black cardboard

According to Agelou Ioannis, "The client wanted an eye-catching image that would immediately draw people's attention. The image of the eye is one from a personal exhibition entitled 'Screens of memory'."

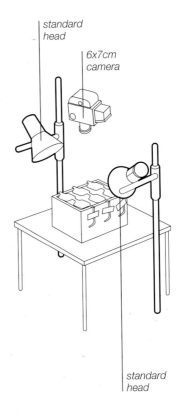

standard head

6x7cm camera

standard head

plan view

key points

A classic look is less prone to the vagaries of fleeting fashions for an image that needs a longer shelf-life

Sometimes illumination is all that is required rather than creative lighting to produce an image with impact

"The image was computer-manipulated in the first place, then duplicated and reversed, combined in pairs, altered in size and perspective in order to form the 'faces'. The colour of each face was altered. The final result was ink jet printed on high-quality matt finish paper that was strapped on a wooden base, eyeglasses fastened on it and photographed from above on a typical copying stand, i.e. a pair of 45 degree lamps. All glass was removed from the frames. Special attention was taken to avoid showing any brand names. A very satisfied customer reported that the poster stopped people walking out of his shop right in their tracks."

photographer's comment

We juxtaposed classical frames on a modern approach background conveying the feel that classic is always 'in vogue' without promoting any particular brand. The shot was conceived strictly as an eye-stopper.

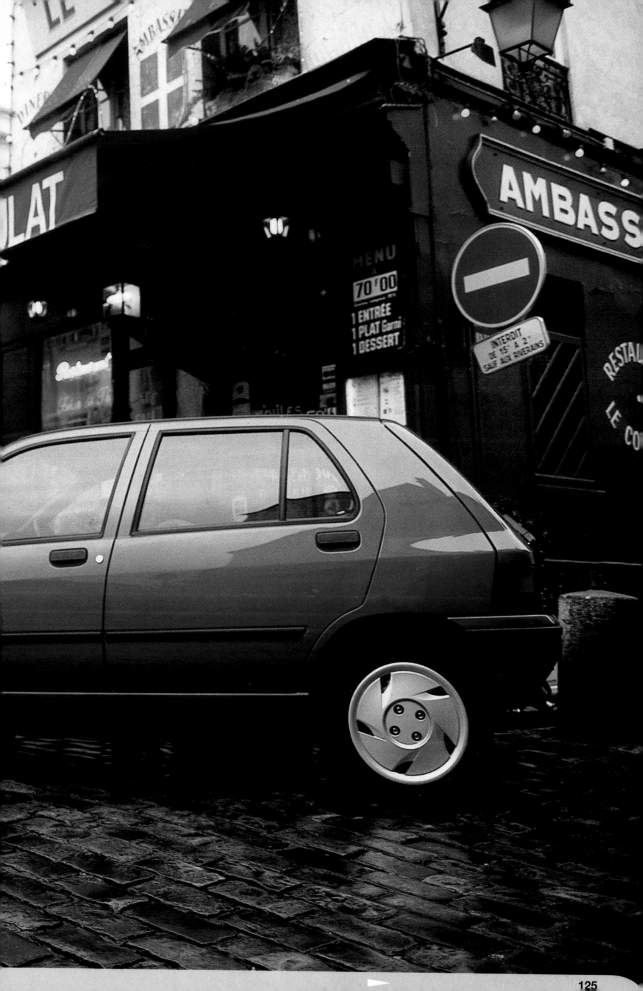

RENAULT

photographer **Alan Randall**

use	advertising
client	Renault
camera	4x5 inch
lens	150mm
film	Fuji Velvia
exposure	1/15 second at f/22
lighting	available light
props and	
background	a French restaurant

A car – the ultimate fashion accessory! The concept behind this commercial was to demonstrate that the car was very suitable for people with a fast lifestyle.

plan view

4x5 in camera

key points

Be very vigilant and watch for unwanted reflections when photographing cars

When motion blurring is required, Polaroid tests and good record-keeping is highly recommended

The woman in the shot was a fashion buyer and is deliberately photographed as a slight blur of movement to make the point that she is busy and always on the move. She is carrying a red bag as this links in with the restaurant sign and balances the composition. The background to the shot was chosen to show off and contrast with the car, the car being the only blue element. A coral graduated filter was used to warm up the sky and the white background building. Finally the cobblestone road was wet down so there would be a good sheen from the light of the overcast day.

COKE CAN

photographer **Corrado Dalcò**

client	Coca-Cola
	(Leo Burnett - Italy)
use	poster
model	Marco Paolucci
assistant	Francesca Passeri
art director	Stefano Volpi
stylist	Alberto Artisani
camera	4x5 inch
lens	120mm
film	Ektachrome 6105
exposure	1/60 second at f/6.8
lighting	electronic flash

The hero Coke can seems to fly out of the image towards the viewer – an effective device for a poster shot – and one that is achieved by using a shallow depth of field so that only a small amount of the can area is actually sharply in focus.

4x5in camera

standard head

standard head

plan view

key points

Be careful to avoid lens flare when back lights are pointed directly towards the camera

Camera movements can be used to render an image soft as well as sharp, as desired

The softness of the rest of the image is what gives it the three-dimensional sense of movement. The branding of the product is so strong ad familiar that in this particular product shot the legibility of all the writing on the product is not an issue.

We all know this particular product automatically, so it is more a question of producing a new and fresh look to promote a familiar item. Again, this is a case where a soft drink has become the ultimate fashion accessory – hence the shot of the male model.

The frontal light, which is a standard head to the right of the camera is direct on the Coke can and also illuminates the image of the model which acts as a background to the shot. The other light used in this shot is the back light which is diagonally opposite the key which provides just enough separation to give a sense of recession between subject and background.

FASHION ACCESSORIES

GOLD SHOES

photographer **Alan Randall**

use	Vogue editorial
camera	4x5 inch
lens	150mm
film	Fuji Velvia
exposure	1/60 second at f/22
lighting	electronic flash

This almost surreal image was in fact created using a relatively straightforward lighting set-up.

4x5in
camera

soft box

plan view

key points

Dulling spray can be used to reduce the shininess of reflective surfaces

Colour is a key element to any composition, even in black and white, colour is responsible for tonal renditioning

The gleaming nature of the shoes is the perfect textural surface to get a good play of light, and Alan Randall has capitalised on this by placing a single soft box source to the right of the camera at an angle. No reflectors or additional equipment was used.

The highlights on the upper surfaces of the shoes give a good sense of modelling, and the composition and styling of the items provide a satisfying visual impact and interest.

The golden glowing colour is purely factual: there is no filtration or specialist treatment. The right props and the right film, are all that is needed to create this stunning look.

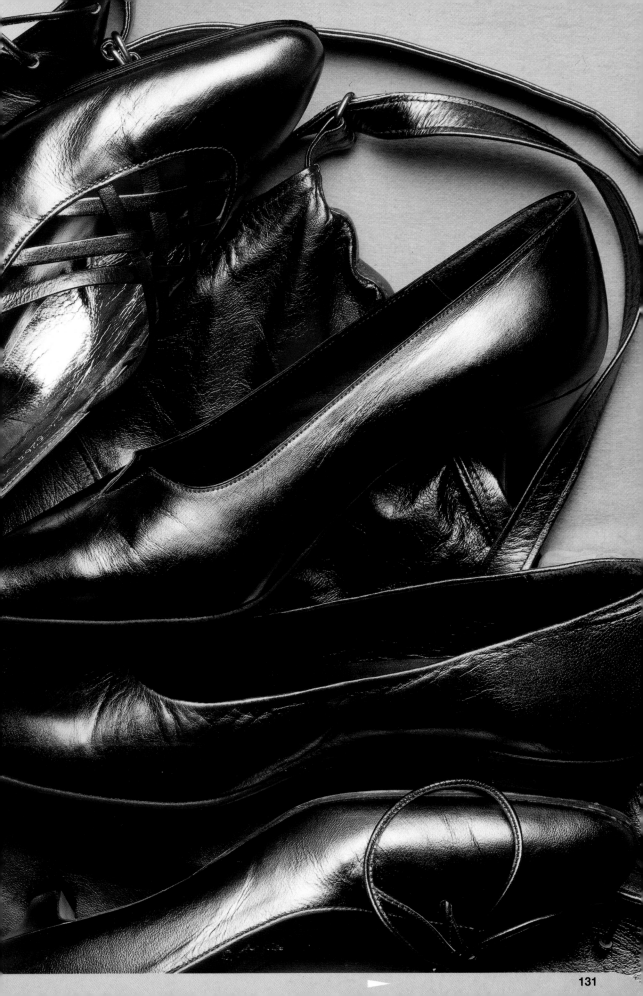

FOSSIL GLASSES

photographer **Corrado Dalcò**

client	Fossil Italia
use	personal work
assistant	Alberto Artesani
art director	Corrado Dalcò
camera	4x5 inch
lens	120mm
film	Vericolor HC4325
exposure	1/60 second at f/6.8
lighting	electronic flash
props and background	glasses on a metal slab

Simple items such as a pair of sunglasses can actually hold a multitude of compositional difficulties and lighting challenges. It also offers scope for interesting lighting possibilities.

standard head with red gel

soft box

4x5 in camera

soft box

plan view

key points

Watch out for reflections in glass surfaces

The positioning of branding names sets a compositional challenge

In this case Corrado Dalcò has chosen to go for a relatively straightforward lighting set-up in order to get the cool sophisticated an uncomplicated look of this shot. A large soft box is directly overhead and another soft box is to the right of the camera. A standard head to the left of the camera adds colour by means of a coloured gel.

Adding characteristic intensity of colour and contrast is the cross-processing: in this case C41 film has been processed in E6 chemistry.

COLLIER DE CHIEN

photographer **Jeff Manzetti**

use	advertising
camera	Pentax 67
lens	150mm
film	epl
exposure	1 second at f/32
lighting	HMI
props and	
background	necklace

There are several ways to publicise a piece of jewellery. Photographer Jeff Manzetti presents a unique approach that keeps the viewer wanting more.

standard head

background

Pentax 67

standard head

plan view

key points

HMIs are available in different colour temperatures

Large pools of soft light will make jewels such as diamonds appear like they are small light sources themselves

Jewellry can be presented in the form of a still life showing off close detail of the finery of the craftsmanship involved in the making of the item. However, in this instance, Jeff Manzetti has chosen to place the item around the neck of a beautiful model, and actually only shows a relatively small detail of the jewellery. It does matter, though, that we see only a small proportion of the product. It is the implication that we too could look that stunning if we owned that item. Of course if the image wasn't lit superbly it might be a different matter.

The photographer uses two HMI (daylight balanced continuous) lights with Chimera soft boxes placed either side of the camera, to illuminate the model. This even soft light complements the model's complexion and makes the gems of the necklace radiate with light.

CONCEPTS

07

Some products can stand as a potent symbol for a whole way of life. The product may not be branded, but that is because the product being sold is not really the detailed item in the shot, as such: it is the promise of a certain lifestyle that accompanies the product that we are being seduced into wanting. It is amazing just how evocative some items can be of the life beyond them; of the context that they must come from, and, by implication, the lifestyle that we half believe we will acquire too, if we only subscribe to this particular trapping of that world. We may not always be able to have the whole thing; we cannot all live in Mediterranean villas in sun-drenched valleys, or live lives of leisure on the golf course. But an exquisitely photographed oil bottle will give us enough of the sense of the former lifestyle to feel that we have a little taste of that life; a shot of a quality golf club will make us feel that we might almost come to rank amongst the world-class players if only we use the product. What is being sold in these concept shots is not specifically just the products; it is the ideas behind them and the dreams that go with them.

LIQUID METAL

photographer **Chet Frohlich**

client	Liquidmetal Golf
use	advertising
camera	4x5 inch
lens	210mm
film	Fuji Provia 100
exposure	f/22
lighting	electronic flash
props and	
background	20x24 inch water tub painted flat black, hand painted background (reflected into water), air compressor with small hose and nozzle

"After meeting with company representatives about the inherent qualities of the product, I was asked to furnish possible ideas of photos for their new product," remembers Chet Frohlich.

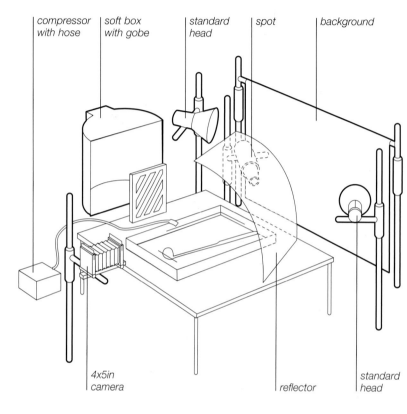

compressor with hose | soft box with gobe | standard head | spot | background

4x5in camera | reflector | standard head

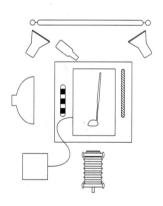

plan view

key points

It is very rewarding creating complicated effects in camera, as well as cheaper, but not always less time consuming

Once a commercial message has been established in the briefing stage, this can act as a potent source of imaginative input for the development of a visual concept

"The most intriguing aspect of the product was the new type of alloy, which the manufacturer called 'liquid metal'. My final idea played on this name. Placing the club head in water creates a startling image that by itself is unusual enough to catch the prospective buyer's attention. The club head rising from 'morning glow' coloured water was to further signify the birth and dawning of a new era in technology.

"The club head was custom-made and polished for this shot. It was packed in the tub which I painted flat black to hide it. The shape and finish of the club is similar to a security mirror and was extremely tricky to light. It was essentially lit with a 20x24 inch light bank (the main light) and a standard head with a 20° spot grid reflecting off silver matte board.

The colour in the water was attained by hand painting a background, then turning it upside down so it would appear correct in the reflection. It was illuminated with two standard heads. An air compressor created the texture in the water."

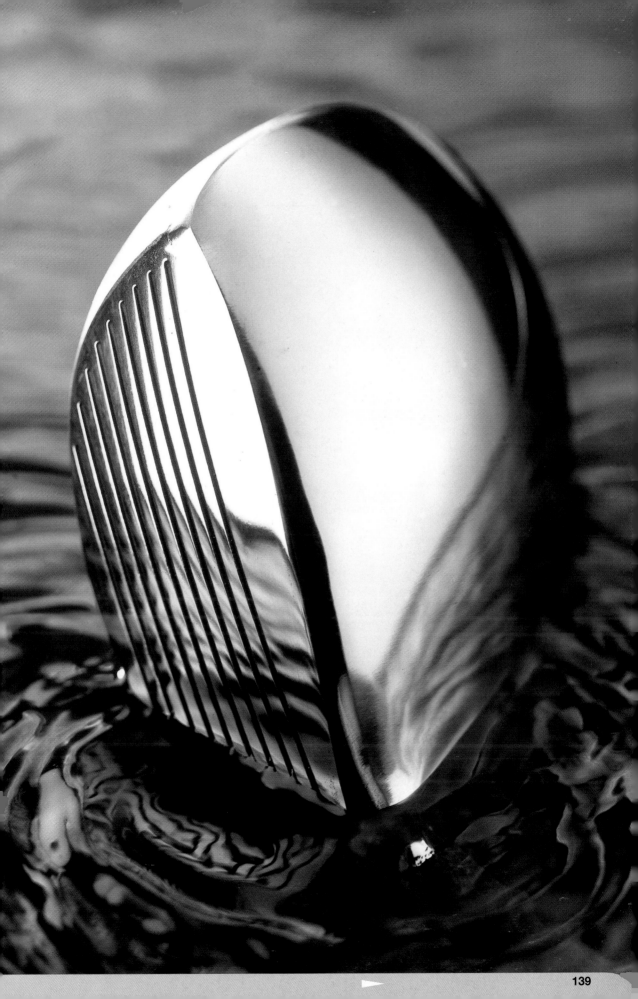

OIL BOTTLE

photographer **Mark Asher**

client	personal work
use	mailshots
stylist	China and Co., West London
camera	4x5 inch
lens	210mm
film	Fuji Velvia
exposure	4 seconds at f/32
lighting	electronic flash, tungsten
props and background	old distressed door with rusty catch

Often when photographing a liquid, it is important to contrive a specific area of back light to shine through and highlight the liquid.

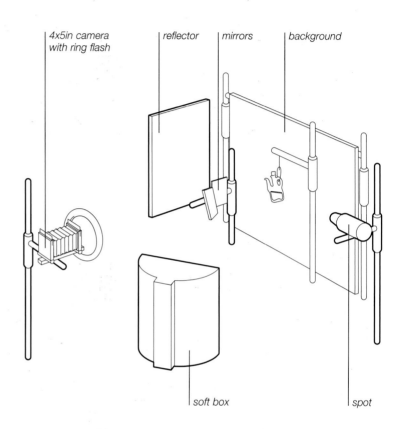

plan view

key points

Limiting the colour range of a shot can dramatically add to the impact

Make sure there are no unwanted reflections when photographing glass

This allows its colour and translucence to gleam and seem to come forward to meet the eye. This set-up demonstrates one way of achieving that controlled area of back light, directed only through the desired area: Mark Asher has used a small piece of mirror board behind the yellow olive oil to reflect the spot light back through the bottle. The main flash and tungsten lights are to the side while a blue-gelled ring flash from camera gives the over-all blue look. This ring flash was used on minimum power with a 201 full correction gel to add the blue shadows. The flash head was at 2000 Joules (reading f/45 on the light meter). The tungsten spot light was allowed to run on for four seconds and was fully corrected to balance it to daylight film.

photographer's comment

The contrast between the yellow and the blue is very striking.

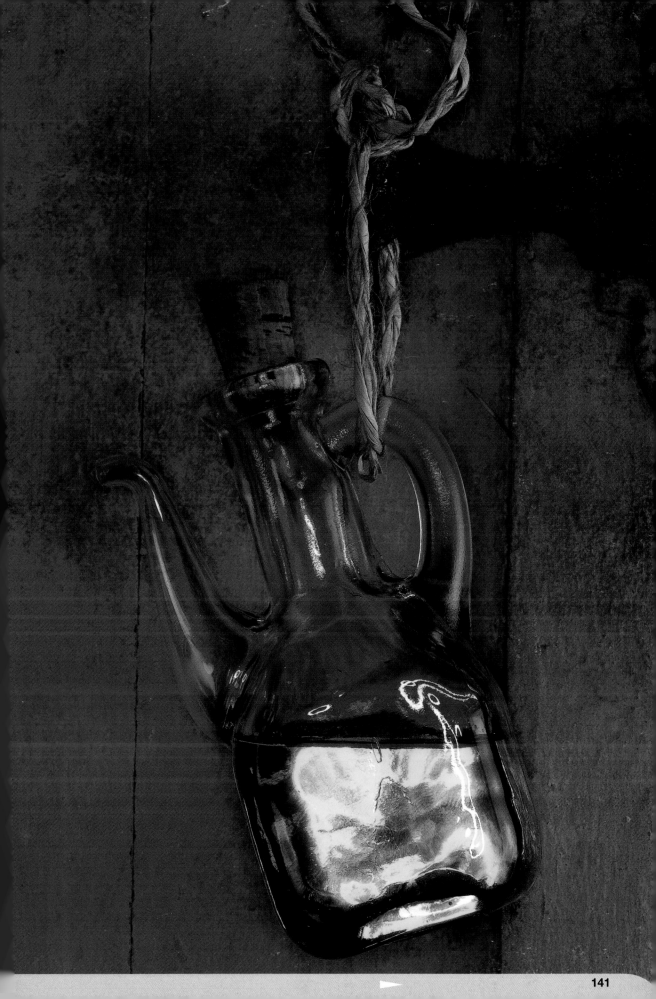

BOILING WATCHES

photographer **Jörgen Ahlström**

client	SAS
use	advertising
camera	4x5 inch
lens	135mm
film	Kodak EPH 100
exposure	not recorded
lighting	electronic flash
props and	
background	white paper

It is interesting to compare this shot with another of Jörgen Ahlström's shots, "The Smell of New York", in that here again he has illuminated the subject only from behind.

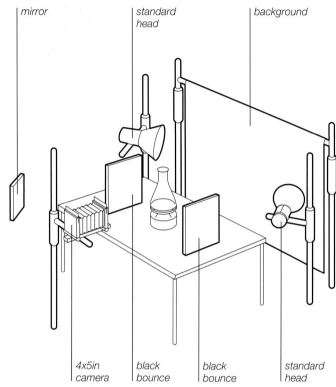

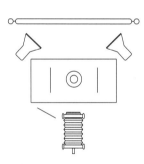

plan view

key points

When focusing through water it is advisable to set the focus before any water is added as diffraction occurs and can be misleading

When working with a naked flame it is good practice to have a fire extinguisher standing by

Once more, a transparent subject is the motivation for this technique. Two standard heads, though placed at either side of the subject, are angled at 45 degrees to bounce off the background, giving essentially a back light. The beaker and the water are transparent so the back lighting adequately illuminates that element of the shot. The Bunsen burner is allowed to stay in dramatic silhouette but, unlike "The Smell of New York" set-up, in this case some frontal reflection is required to illuminate the watches, since they are not transparent subjects. This is done by the use of a make-up mirror on a stand directed so that the watch faces and straps are subtly but adequately lifted. Two black panels provide the reflected black definition to the edge of the beaker.

BUSY FISHES

photographer **Jonathan Pollock**

client	Contract Catering Co.
use	prints in restaurant and promotional
assistant	Liz Leahy
other	Steven Wheeler
camera	4x5 inch with 120 adapter
lens	210mm
film	Kodak 100 Plus
exposure	1/30 second at f/32
lighting	electronic flash
props and background	water tank used for the bubbles

The large soft box at the rear of this set-up acts a backdrop as well as a back light for this shot.

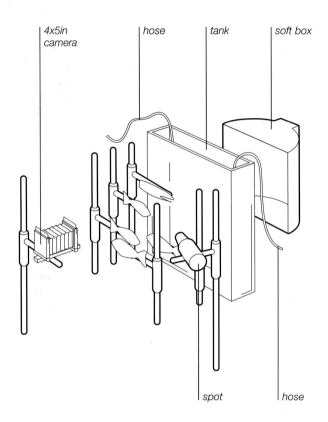

plan view

key points

When working with unpredictable factors such as bubbles within a composition, it is advisable to have lots of shots to choose from rather than too few

As with any fresh food product shot, it is essential to have a plentiful supply of specimens to allow for individual variations

In front of the soft box is a tall water tank through which two assistants blow air bubbles that are captured with a strong sense of movement by the 1/30 second exposure. In front of the water tank we come to the raison d'être of the shot: the fish themselves. These are mounted on a series of rigs and are carefully positioned to give the amusing and busy-looking composition. A standard head to the right of the camera illuminates the fish from the front, some five feet from the subject, while the soft box behind, diffused through the water, provides some separation.

photographer's comment

With the use of strong lighting which creates deep shadows, the viewer is allowed the freedom to catch the character of each fish.

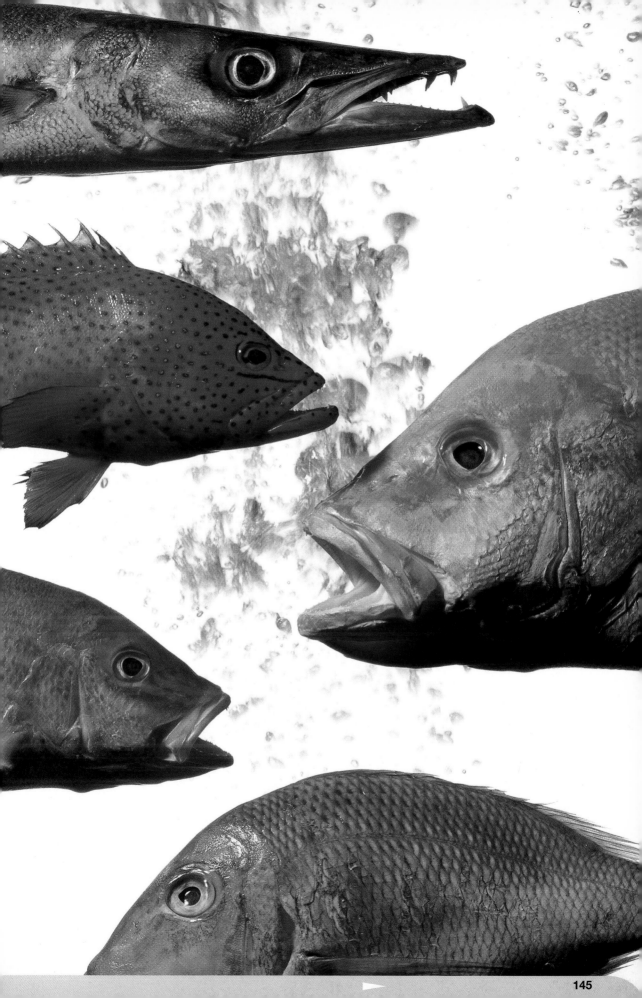

ICE AND A SLICE

photographer **Peter Millard**

use	personal work
camera	8x10 inch
lens	360mm
film	Kodak 6117
exposure	not recorded
lighting	electronic flash
props and background	plastic ice, slice of lemon, carbonated water

Peter Millard provides his own insights and commentary on how this exquisite shot was achieved

8x10in camera · spot · masked soft box

plan view

key points

The ability to resort to lateral thinking is always an asset in creative work

When the result is not exactly what is wanted, consider a range of unconventional as well as the more obvious methods for rectifying the look of the shot during the post-production stage

"The shot was taken against a 0.7 metre soft box, with an additional flash spot light to add a little sparkle to the ice. The ice was plastic, from a display company (Replica Foods) although the slice was real enough!

" The glass was filled with carbonated mineral water as this gave the best bubbles. Exposure was by a single flash in order to make the bubbles as static as possible although there is still movement in some of them.

" The camera was positioned in fro of the glass and in line with the soft b to fully back light the slice of lemon and the final crop was always intende to be very tight indeed. The final imag was chosen for the best placement of bubbles, but looked a little flat so the original was duplicated on Type B, i.e. regular tungsten balanced film rather than dupe stock, to successfully pump up the contrast."

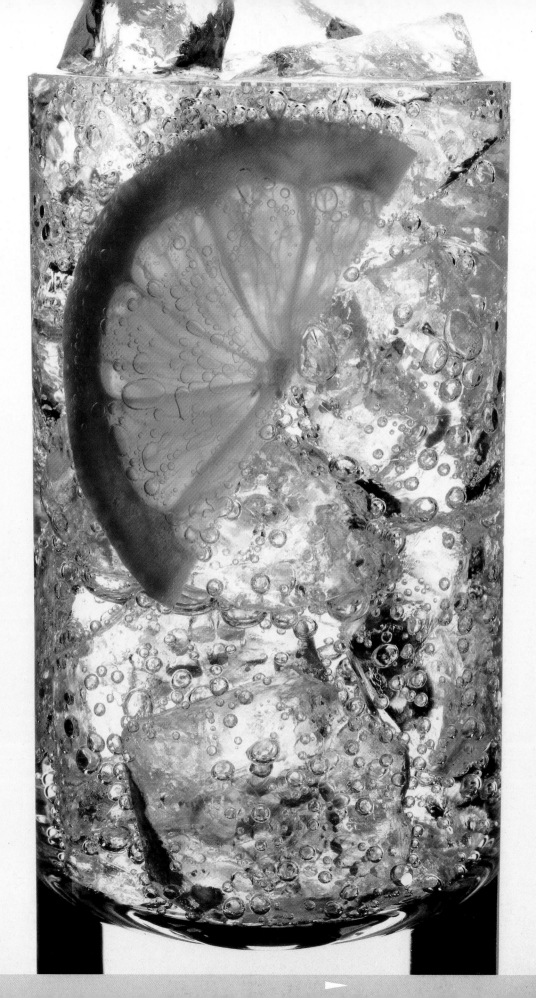

GERBERAS

photographer **Alan Randall**

use	personal work
camera	4x5 inch
lens	150mm
film	Fuji Velvia
exposure	1/60 second at f/22
lighting	electronic flash
props and background	red table, flowers phone

This shot combines a fairly standard studio shot using rigs to hold objects in place, with a location background. The oil itself also is shot separately.

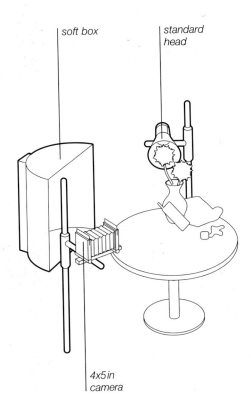

soft box

standard head

4x5 in camera

plan view

key points

It is wise to have a plentiful supply of flowers for a shoot like this as there can be many imperfections in the blooms and also they may wilt under the studio lights

The rape seed field in the background of this image is shot on a wide-angle lens with a polarising filter and a graduated neutral density filter. The tabletop element is in two parts. The main shot, with the vase and flowers, the mobile phone, and the oil bottle and its lid with the puddle of oil, is one shot. This is frontally lit by a soft box to the left of the camera and a standard head three-quarter back lighting. It is interesting to notice that the virtual image of the vase in the red table has a rear highlight which of course is not visible to the eye from the front. The oil pouring is shot separately, but with the same perspective and lighting for continuity. The clothes line shot at left is similar except that there is no back light.

photographer's comment

It is a good idea to be on the look out for devices that can be used as rigs to hold objects in place. Specially made rigs can be bought but why not use cheaper alternatives?

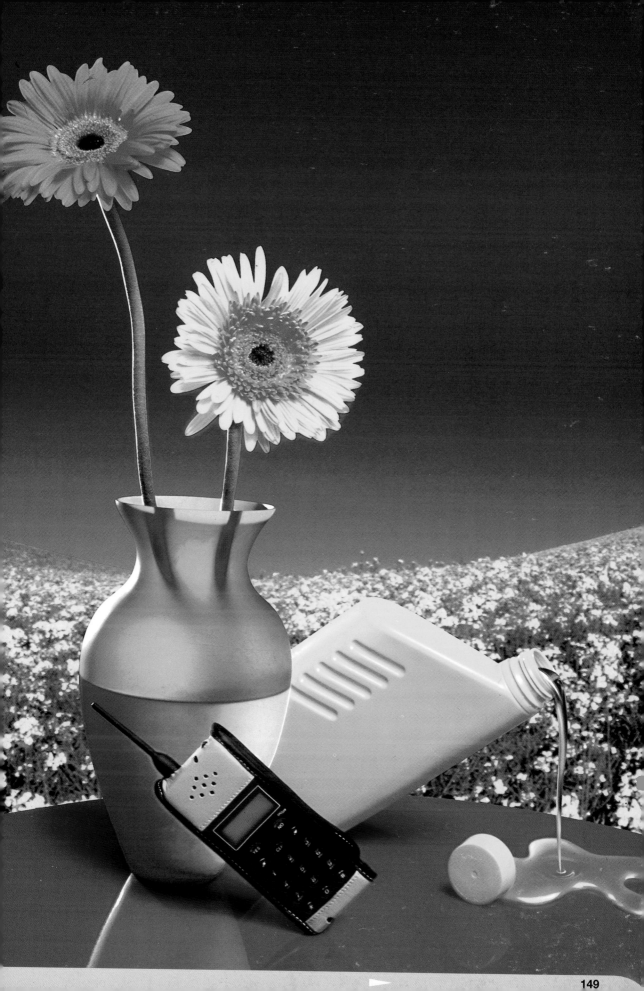

CHEVROLET

photographer **Alan Randall**

use	advertising
client	personal work
camera	4x5inch
lens	150mm
film	Fuji Velvia
exposure	1/60 second at f/32
lighting	electronic flash
props and background	car, stock image, tabletop and vases

This image could have been shot on location in the Bahamas, but in fact was compiled on virtual location in the photographer's digital studio.

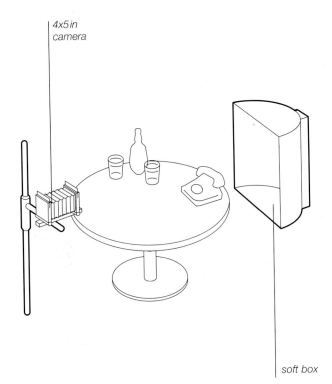

4x5 in camera

soft box

plan view

key points

With composite images, reflections may need to be digitally added, such as the sky in the bonnet of the car

A good library of stock images is always useful to draw on

It is a three-part image, with the various elements combined into a stunning whole. Unlikely though it may sound, it combines a landscape (or more accurately a skyscape) vista, an outdoor location product shot, and a studio still-life into a harmonious single image.

The car image is a stock shot, taken on an overcast day and therefore having even light over the whole body of the car and a good highlight in the front bumper. No reflectors were required. The sunset provides a background but as the sun is visible, this dictates how the set-up component of the final image is lit. The foreground still-life is lit by a soft box from behind.

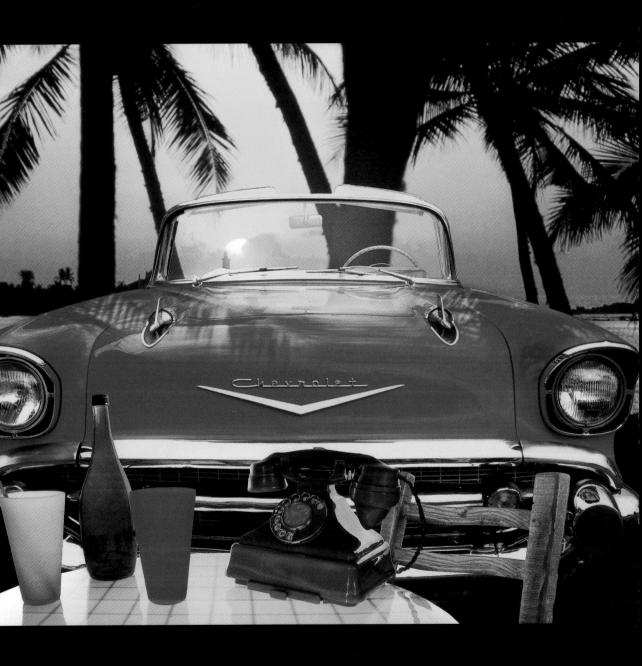

AUDI

photographer **Alan Randall**

A lot meets the eye when you first see this image. But far more is going on than you might imagine.

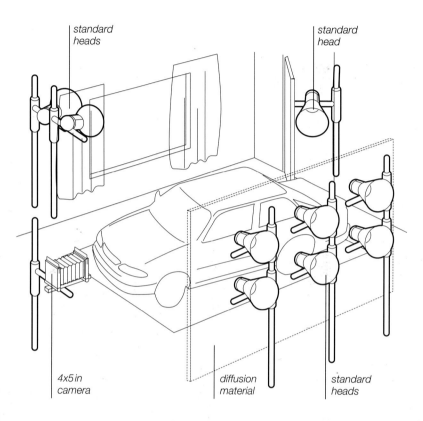

standard heads

standard head

4x5in camera

diffusion material

standard heads

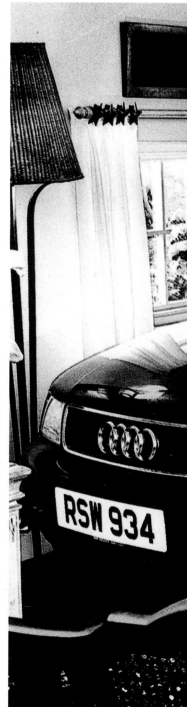

This is not a set; it really is someone's living room with the wall removed to allow the camera to be far enough back without distorting the car too much. The photographer is actually standing in the garden in the pouring rain with a tarpaulin to give some protection. The wall that runs parallel to the visible long edge of the car was painted white and six tungsten heads at even intervals are bounced off the wall and through a translux or large sheet of diffusion material. This side of the car was then used to take a meter reading and used as a basis for balancing the intensity of the rest of the lamps.

The other factor is the candles on the mantelpiece. A suitably long exposure is required to record anything at all; but then, the dog has to stand still for longer... of course, there are ways around this with a bit of creative thinking!

se	advertising
ient	BBH/Audi
amera	4x5 inch
ns	150mm
lm	Ilford EP4
xposure	1 second at f/32
ghting	tungsten
ops and	
ackground	a house interior

key points

It is good to have a selection of higher output domestic lamps for prop lights which also act as sources

Creased silver foil can introduce interest in light reflections as in the background of this image

plan view

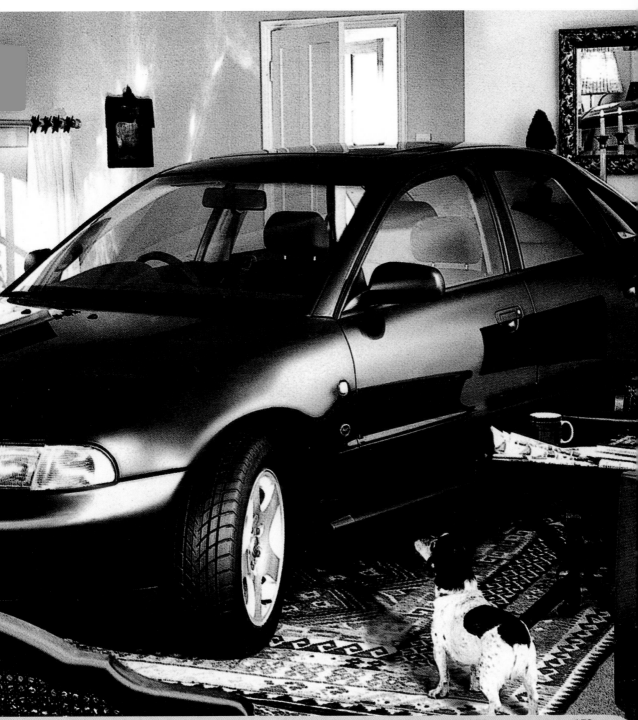

DIRECTORY of PHOTOGRAPHERS

08

photographer	**Jörgen Ahlström**
address	Norr Mälarstrand 12
	112 20 Stockholm
	Sweden
telephone	+46 (8) 650 5180
fax	+46 (8) 650 5182
agent	The Purdy Company Ltd
(England)	7 Perseverance Works
	38 Kingsland Road
	London E2 8DD
	England
telephone	+44 (0)171 739 3585
fax	+44 (0)171 739 4345

pp: 55, 143

photographer	**Mark Asher**
studio	Fox Studios
address	32-36 Telford Way,
	London W3 7XS
	England
telephone	+44 (181) 232 8368
mobile	0378 192 429
fax	+44 (181) 232 8368
email	mashergt6@aol.com
biography	Ten years industry experience, specialising in still-life and food but I still like to do work in other areas when the opportunity arises, such as digital imaging and manipulation. Clients include BBC Worldwide, Collin and Brown Publishing, Clover Haywards, Immergut-Milch, Radio Times, Sainsbury's and *Which Magazine*.

pp: 88, 141

photographer	**Ben Lagunas and Alex Kuri**
studio	BLAK PRODUCTIONS
address	Galeana 214 Suite 103
	Toluca, Mexico
	C.P. 50000
telephone	+52 (72) 15 90 93
	+52 (72) 17 06 57
fax	+52 (72) 15 90 93
biography	Ben and Alex studied in the USA and are now based in Mexico. Their photographic company, BLAK PRODUCTIONS also provides

full production services such as casting, scouting, models, etc. They are master photography instructors at Kodak Educational Excellence Center. Their editorial work has appeared in international and national magazines, and they also work in fine art, with exhibitions and work in galleries. Their commercial and fine art photo work can aslo be seen in the *Art Director's Index* (Rotovision); *Greatest Advertising Photographers of Mexico* (KODAK); the ProLighting Series (*Nudes, Protraits, Still Life, Night Shots, Intimate Shots, Beauty Shots, Fashion Shots, Erotica* and *New Product Shots*); and other publications. They work around the world with a client base that includes advertising agencies, record companies, direct clients, magazines, artists and celebrities.

pp: 21, 47

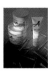

photographer	**Ricardo de Vicq de Cumptich**
studio	RVC Produções e Studio de Fotografia Ltda.
address 1	Rua Pedro Teixeira, 91
	04550-010
	São Paulo SP
	Brasil
address 2	Rua Irauna, 202
	04518-060
	São Paulo SP
	Brasil
telephone 1	+55 (11) 866 0549
telephone 2	+55 (11) 828 0085
fax 1	+55 (11) 866 4018
fax 2	+55 (11) 866 1107
email	rvicq@macbbs.com.br
biography	Ricardo de Vicq de Cumptich, 47, was born in Rio de Janeiro and has lived in São Paulo since 1985. His editorial work has appeared in *Vogue, Elle* and *Marie Claire,* but the majority of his work has been in advertising. His portfolio includes personal work on nudes, landscapes and a large work from Roberto Burle Marx Gardens. His specialities include food, beverage,

portrait, still life and nudes. Almap/BBDO, DPZ, J.W. Thompson, Leo Brunett, McCann-Erickson, Salles DMB&B, Young & Rubican, F. Nazca and Saatchi & Saatchi are among his clients. He has received awards from the Cannes Festival, International Advertising Festival of NY, Clio Awards, London International Advertising Awards and The Art Directors Club Inc., among others.

pp: 63, 84

photographer	**Corrado Dalcò**
address	via Sciascia 4-43100
	Parma, Italy
telephone	+39 521 272 944
fax	+39 521 778 8434
email	imadv.mbox.vol.it
biography	Corrado Dalcò was born in 1965 in Parma. He studied for five years at the P. Toschi Institute of Art in Parma, specializing in graphic design. He is a self-taught photographer, working as a freelance photographer abroad before founding his own photographic studio in 1991. He won an international competition in 1993 ("5ième Biennale") for young Italian photographers and his photos were published in the Photo Salon Catalogue. At present, Corrado works mainly with agencies in Milan, concentrating on fashion. Some of his work is also published in several Italian and international magazines.

pp: 128, 133

photographer	**Chet Frohlich**
studio	Chet M. Frolich Photography
address	1030 Calle Cordillera #107
	San Clemente, California
	USA 92673
telephone 1	+1 (949) 366 0781

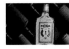

lephone 2	+1 (714) 366-0781
nail	cmfphoto@ix.netcom.com
RL	www.san-clemente.com/cfphoto/
	pp: 45, 139

notographer	**Tony Hutchings**
ddress	7 Luke Street, London EC22A 4PX England
lephone	+44 (0) (171) 729 8181
x	+44 (0) (171) 729 9322
nail	tonyh432@aol.com
ography	Tony specialises in creative still life photography, often using strong direct lighting to bring out graphic shapes and colours. Recently he has been working with advertising agencies overseas using the Internet and websites to show work in progress. Contact Tony by email at the address above. **pp: 19, 26**

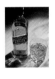

notographer	**Agelou Ioannis**
tudio	Agelou Ioannis Imaging
tudio address	49 Xalkidikis str. T.U. 546 43 Thessaloniki Greece
ail address	PO Box 50797-54014 Thessaloniki Greece
lephone	+30 (0) (31) 813772
ax	+30 (0) (31) 813772
obile	+30 (0) (94) 257125
mail	agelou@classic.diavlos.gr
iography	Commercial still-life and portrait photographer with clients throughout Greece. Teacher of photography and writer. Interested in alternative and mixed light lighting techniques. Increasingly involved in digital imaging and fine art photography. He likes to broaden his vision constantly: "We have to cultivate our garden constantly." **pp: 22, 57, 61, 75, 123**

photographer	**Jeff Manzetti**
studio	Studio Thérèse
address	13 rue Thérèse Paris 75001
telephone 1	+33 (1) 42 96 24 22
telephone 2	+33 (1) 42 96 26 06
fax	+33 (1) 42 96 24 11
biography	Jeff Manzetti has been a photographer for the past 12 years. His work took off rapidly, beginning with campaigns for international clients such as Swatch (worldwide), Renault, Lissac, Dior and L'Oreal, as well as many editorials for *ELLE* magazine. Jeff's work has always focused on beauty and personalities. His work has appeared as covers and spreads in *Figaro Madame, DS, Biba,* and *20 ans.* He has had the opportunity to photograph well-known celebrities such as Isabelle Adjani, Isabelle Huppert and Sandrine Bonnaire. His energy and humour extend to his work, as reflected in his advertising campaigns for Cinécinema and Momo's restaurant in London. He has also directed numerous videos and commercials in France, to great acclaim. **pp: 121, 135**

photographer	**Catherine McMillan**
address	11105 Leafwood Lane Austin, Texas USA 78750
telephone	+1 (512) 335 8449
fax	+1 (512) 335 8449

biography	A graduate of Brooks Institute, I had a studio in San Francisco for five years. Clients include Mervyn's California, Levis Strauss, Mary's California, Nechirei Seafood and Holland Sport. I worked in Germany for *Essen* and *Trinken* food magazine as well as *Bild du Prau* magazine. **pp: 83**

photographer	**Ron McMillan**
studio	McMillan Studios Limited
address	The Old Barn Black Robins Farm Grants Lane Edenbridge Kent TN8 6QP
telephone	+44 (0)1732 866 111
fax	+44 (0)1732 867 223
biography	Ron McMillan has been an advertising photographer for over twenty years. He recently custom-built a new studio, converting a 200 year old barn on a farm site, on the Surrey/Kent borders. This rare opportunity to design his new drive-in studio from scratch has allowed Ron to put all his experience to use in its layout and provision of facilities including a luxury fitted kitchen. Ron's work covers food, still life, people and travel and has taken him to numerous locations in Europe, the Middle East and the USA. **pp: 65, 67,**

photographer	**Peter Millard**
address	5A Scampston Mews London W10 6HX
telephone	+44 (0)181 968 1377
fax	+44 (0)181 968 0104
email	pjmillard@compuserve.com
biography	Born in Liverpool (England), in 1960, I started freelancing immediately after graduating

from college (Harrow, BA in Photography, Film and TV, 1981) first as an assistant, then as a photogapher. I've had my own studio for the last ten years or so, and as an experienced still-life photographer my clients have included household names such as Proctor & Gamble, Avon Cosmetics, Marks and Spencer, Nationwide and Marlboro, both direct and through agencies and design companies, plus a host of smaller clients and companies. In addition to my still-life product work, I also photographed children for approximately four years, and at last count have around 130 children's books illustrated by my pictures currently in print worldwide.

pp: 29, 35, 36, 48, 93, 94, 147

photographer	**Romylos Parissis**
address	5 Alkeou St.
	Athens M5 28
	Greece
telephone	+3 01 7715771
fax	+3 01 7481522
biography	Self taught, Romylos Parrisi worked as a cameraman for a number of years and as a photographer's assistant before branching out on his own as a freelance commercial (still life) photographer. He is currently based in Athens with clients throughout Greece. He has worked extensively with the Greek Tourist Board and various agencies. More recently, he has specialised in photographing objets d'art, as well as location photography, touring Europe photographing churches and other sites of interest. His photography is a combination of

interiors and product shots, with an emphasis on space and landscape.

pp: 103

photographer	**Jonathan Pollock**
studio	Offshoot Studios
address	Crowndale Centre
	218 Eversholt Street
	London NW1 1BD
	England
telephone	+44 (0)171 387 8427
fax	+44 (0)171 387 2143
mobile	+44 (0)831 891 267
biography	Jonathan began his career in photography on his eighteenth birthday, when he received a camera as a gift from his godmother. At first he taught himself, until his interest grew and to gain more experience Jonathan started as an assistant in various photographic studios in London (England). By 1985, he had developed a keen interest in the area of food and still life. The success of his pictures enabled him to set up his own studio in 1988. Jonathan's preferred camera is the 5/4 which introduces the challenge to broaden the scope for new work.

pp: 91, 105, 106, 145

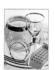

photographer	**Alan Randall**
studio	Canonbury Studio
address	36a Canonbury Square
	London N1 2AN
	England
telephone	+44 (0)171 226 1642
mobile	+44 (0)850 595 544
fax	+44 (0)171 226 1201
agent	Marion Enste-Laspers
(Germany)	Servicepool

Ackermannsstrasse 21
D-22087 Hamburg

telephone	040 22 22 26
fax	040 22 10 62
agent	Julian Cotton
(England)	55 Upper Montague Street
	London W1
telephone	+44 (0)171 486 3307
fax	+44 (0)171 486 6565
biography	Alan Randall was educated in London and Scotland. He graduated from Hornsey College of Art with a B.A. (Hons) Degree, and then worked in design, graphics a▮ photography. His work includ still life, cars, room sets and variety of work in the studio and on location. He has worked throughout the world for all the major advertising agencies, in both stills and film. These include J. Walter Thompson, Saatchi & Saatch Ogilvy & Mather, McCanns, Collett Dickens & Pearce, Young & Rubican, Interpublic Dorlands, Leo Burnett, Geers Gross etc. His list of clients includes Ford, Peugeot, Saab, Heinz, Cadbury-Schweppes, Burberry, Barclays Bank and British Telecom. He has also directed commercials for general Motors in New Zeala and American Express in New York.

pp: 52, 115, 117, 124, 131, 149, 151, 152

photographer	**Renata Ratajczyk**
address	323 Rusholme Road, #1403
	Toronto, Ontario
	Canada M6H 2Z2
telephone	+1 (416) 538 1087
fax	+1 (416) 533 9569

email	renatara@ica.net
URL	http://www.virtualcolony.com/renatar/
URL	http://www.lastplace.com/EXHIBITS/CyberistHall/Renata/catalog1.htm
biography	Renata is photographer and digital artist. Her work includes fashion, fine art portraiture, as well as editorial, travel and advertising photography. She has developed a very painterly, imaginative, often surrealistic style. She often enhances her work by a variety of techniques including hand-colouring and digital imaging. Her work has been published in a variety of magazines, on book covers, in calendars, on greeting cards and has been used for advertising. Renata has her own stock library and is represented by several stock agencies. Her studio is located in Toronto, Canada.

pp: 110

photographer	Chris Rout
address	9 Heythrop Drive
	Acklam
	Middlesborough
	Cleveland TS5 8QA
telephone	+44 (0)1642 819 774
mobile	0374 402 675
biography	A trained commercial diver at 21, Chris went on to train as an underwater photographer. He progressed into freelance photography eight years ago. A successful professional photographer specialising in fashion and lifestyle stock photography, he is based in the north-east of England. Chris has his own studio and regularly takes commissions from various clients.

pp: 98

photographer	Bob Shell
address	1601 Grove Ave.
	Radford, Virginia
	USA 24141
telephone	+1 (540) 639 4393
fax	+1 (540) 633 1710

email	bob@bobshell.com
biography	Bob is the editor of *Shutterbug*, the world's third largest monthly photo magazine, and is on the technical staff of *Color Foto*, Germany's major photo magazine. He has also been editor and publisher of a major UK photo magazine. His photographs and articles have been published in books and magazines all over the world, and he is the author of a number of titles on photographic topics.

pp: 68, 77

photographer	Gordon Trice
studio	Gordon Trice Photography
address	774 E. North 13th Street
	Abilene, Texas
	USA 79601
telephone	+1 (915) 670 0673
fax	+1 (915) 676 4672
email	gordon@bitstreet.com
biography	Gordon Trice, 50, has been working in the editorial, advertising and corporate arena since 1968. His earliest experience was editorial. As a corporate staffer in aviation, he learned about various print media and graphic arts. He has worked for newspapers, wire services, magazines and corporations worldwide. His current work focuses on product photography in studio and on location.

pp: 72, 113

photographer	Nick Welsh
studio	Nick Welsh Photographs
address	15, rue Pre-De-La-Fontaine
	1217 Meyrin
	Switzerland
telephone	+41 22 785 55 23
fax	+41 22 785 55 65
agent	Laurence Torjdman
address	96, rue du Marechal Joffre
	92700 Colombes
	France
telephone	+47 84 83 30
fax	+47 82 67 28

pp: 81

photographer	Martin Wonnacott
studio	The Cat's Back Studio
address	4d Farm Lane Trading Centre
	Farm Lane, Fulham
	London SW6 1PU
telephone	+44 (0)171 386 5300
mobile :	+44 (0)831 806 007
fax	+44 (0)171 386 5377
email	martin@catsback.co.uk
agent	Julian Cotton
(England)	55 Upper Montague Street
	London W1
biography	I specialize in liquid and drinks photography which I find extrememly rewarding. I started working in a commercial studio as a third assistant on a Youth Training Scheme 13 years ago and now I have my own studio in Fulham Braoadway (London, England). I work for various advertising agencies and enjoy every single working day.

pp: 31, 33, 40

ACKNOWLEDGMENTS

First and foremost, many thanks to the photographers and their assistants who kindly shared their pictures, patiently supplied information and explained secrets, and generously responded with enthusiasm for the project. It would be invidious, not to say impossible, to single out individuals, since all have been helpful and professional, and a pleasure to work with.

We should like to thank the manufacturers who supplied the lighting equipment illustrated at the beginning of the book: Photon Beard, Strobex, and Linhof and Professional Sales (importers of Hensel flash) as well as the other manufacturers who support and sponsor many of the photographers in this and other books.

Thanks also to Brian Morris, who devised the PRO-LIGHTING Series, Simon Hennessey and Norman Turpin who made certain the books were as good as they could be, and Keith Ryan.